NOT AFRAID TO SLAY

NOT AFRAID TO SLAY

WOMEN OF THE HAUNT INDUSTRY

JAN KNUTH

WITH CANDI S. CROSS

DEDICATION

During the editing of this book, my mother Monica Skaggs, died from COVID-19 on April 20, 2021. She was an amazing mother, an inspiring person, and the one who taught me to be me, to speak my mind, and to always believe in myself.

As I came back to my desk after tending to my mom during her illness, planning the funeral, and reeling from the shock, I found my book laying where I left it four weeks earlier with my pen and highlighter still between the pages. My biggest regret will always be that my mom, my biggest cheerleader, will never read this book.

I dedicate this book to my mom.

Mom, I promise, they will always hear me coming.

TABLE OF CONTENTS

ACKNOWLEDGEMENTS

ON A SUMMER day in 2018, I took my friend and co-author, Candi Cross, on a tour of my Halloween haunted house, Grey House Haunts, in Holdrege, Nebraska. It was hot, dusty, and noisy with general chaos everywhere, and she asked me, "You run this all yourself?"

"Yes, with help from a couple of assistants here and there," I said.

She looked at me with surprise and said, "Girl, *this* is a story for a book!"

In 2020, many haunts weren't able to open, including Grey House Haunts. It took me months to come to this conclusion: Actively being involved and owning a haunt at fifty-five years old limits the number of years I can participate, and now, I've lost one year. I was grieving. My beloved Grey House, my happy place, was closed for the season. My husband, Steve, saw how I was struggling without any scares to develop, no costuming to be done, no lights to set, and he called Candi, shouting "She needs a project, now!"

So, Candi and I went off on an adventure that I never would've imagined could happen—writing a book about the haunt industry.

Without Candi Cross, there would be no book. I can't thank her enough for her enthusiasm, knowledge, and guidance.

Without my husband, Steve Knuth, there would be no Grey House Haunts, as he believed I could do it and convinced me of the same. My husband's support of the haunted attraction, my passion for it, and this book is extraordinary and genuine, and for that, I am eternally grateful.

Many people have helped me along the way since I put up a display with Halloween characters in my yard, to the opening and running of Grey House. There are too many to list, but some stand out.

The many volunteers for the 'home haunt' to the staff at Grey House, who make it come to life each October, thank you just isn't enough. May we have many more Halloween seasons together.

My best girl, Shai Stroh, who is my creative assistant and niece. Without her, Grey House would never have been as fun or as deliciously diabolical as it is. Our ability to read each other's minds has come in so handy!

My sister, Jo Breinig, who keeps me going, brainstorms with me, runs the 'front of house' and tolerates my meltdowns on opening night, every single year. Props for propping me up.

My "tons": Preston Rath, Boston Petit and Auston Marshall. Thanks for helping me to build Grey House. I learned so much from you all. I only hope you learned half as much from me.

My family, who act, build, and cashier, thank you for your support and dedication.

Last but not least, the contributors to this book, the people that have taken the time to teach others about this weird and unusual industry: LaNelle Freeman, Jes Murphy, Melissa Winton, Sylvia Vicchiullo, Mandy Redburn, Caisey Cole, Scott Swenson, Allen Hopps, Shannon Hopps, Sue Gray, and Brian Foreman. I can't thank you all enough for your time, wisdom and insight, but mostly for inspiring me to continue to move along the path.

With that, as I say every night when the haunt actors rush off to dark places in a flurry of capes and dust to scare and entertain, "Be scary and FLY MONKEYS, FLY!"

Home is Where the Haunt Is

*"It is women who love horror. Gloat over it. Feed
on it. Are nourished by it. Shudder and cling
and cry out—and come back for more."*

—*Bela Lugosi, actor*

I T HAS EIGHT eyes, eight legs, and hisses as it senses the vibrations of your movement. You come closer, innocent passerby as you are, and it rears fangs designed to impale prey. All eleven inches of the imposing brown Goliath bird-eating spider may be your worst nightmare.

Or is it a wall of Cuban boa snakes in a bat-filled cave? The very sight of their jewel-colored, slick skin and beady eyes freezes every part of you except for your fleeing heart.

What about standing in the center of the bone-chilling Paris Catacombs? Legend has it that tourists have become disoriented or even gone mad in the network of tunnels because suddenly, they didn't know how to escape.

Roller coasters.

Airplanes.

Blood.

Looking over the edge of a cliff.

Coronavirus.

A-ha! You're taking notice. Your pulse is racing.

Did quarantine, homeschooling your kids, tending to the mental health of your pets, or running out of toilet paper scare you? Or did the threat of a virus roaming in the air you're breathing? I specialize in scare experiences, and *that* terrified me. Not to mention murder hornets, venomous caterpillars, the puppy born with green fur, and hungry monkeys taking over a city—all real scenes of the year, 2020.

But while contemplating life during a pandemic and keeping up with horrors in the news, something amazing happened. My creativity stirred. Newfangled fears sparked the need to be even more productive than I usually am. I set out to design new configurations for my Halloween attraction, Grey House Haunts. I worked the entire summer of 2020 with the knowledge that we would not be open for at least seventeen or eighteen months. Though I figured out how I could open during the height of a pandemic, I was not going to. It would have been irresponsible to put thousands of people through that house. I was very concerned with getting my staff sick. Customers would be under much less risk. But with the staff encountering 3,500 people, someone would inevitably have COVID. I refused to compromise the quality of my show. We are physically small in a challenging geography (rural Holdrege, Nebraska), but we pride ourselves on producing a high-quality show. In fact, someone recently told me that our sets are as good as one of the most respected haunted attractions in the country. That's a comment I don't take lightly.

Critical thinking in lockdown helped me devise new ways to interact with people, do makeup, train staff, and operate the physical space of my humble house. I also started writing this

book, which kept my spirits up in spite of a dark and gloomy winter. My ultimate inspiration was talking with a dozen kickass women (and "a few good men") in the haunt industry.

All of these outstanding individuals were willing to share their personal stories, business insight and even savvy tips, to my astonishment. After all, the haunt world is well-known for being secretive. Our greatest weapon is *surprise*. Still, the amount of sheer genius in haunt architecture, technology, costuming and makeup, actor training, theatre and expression, marketing, education, and overall storytelling splattered on these pages makes my heart race with excitement. Often written off as hobbyists by mainstream society, we're walking encyclopedias. We don't give ourselves enough credit. But it's time.

Prior to "C-19" 2020, we were experiencing a surge in Halloween aficionados hitting haunted houses nationwide, year over year. The US leads the world in hauntings. We are the experts. Australians and Europeans are contacting our discussion groups alerting us that it's taking hold there. It's becoming bigger in Japan, too. America Haunts estimates that over $25 million of haunted house equipment, services and supplies were shipped to other countries in Asia and Europe.

The US made Halloween a commercial industry and second only to Christmas. The National Retail Federation conducts an annual Halloween survey and estimates that total Halloween spending reached $8.4 billion in 2016, a record high in the survey's eleven-year history. Over the next few years, movie industry vets widely crossed into haunted house territory to explore the darker side of their skills and training. High-quality trade shows were offering an array of animatronics eye candy—"Pennywise," "Krampus," and "The Hand" are definitely among my favorites. Escape rooms, seasonal immersion experiences and buyout private events of the ghoulish kind were giving new meaning to Ministry's song, "Every Day is Halloween." It's coming true.

Last I checked (today, the first day of spring), the Halloween Forum had 67,500 members and a full discussion forum on topics ranging from prop sales and animatronics workshops, to best themed sheet music, collectors' Spirit catalogues wanted, and haunted birthday party tips.

What things that go bump in the night will 2021 bring? For one, KISS, my favorite band from the 70s, announced their "End of the Road Tour"! This is so fitting toward my own perspective about the theatrical because though I always liked monster movies, it was not because I might see the next Goliath spider or killer clown. I was always obsessed with transformation. KISS is the poster child for transformation, flamboyance, and the power to express oneself.

I loved dressing up for Halloween in order to "be" someone else. Horror has not been my thing. I use horrific elements in the haunt, but Freddy and the doll, Annabelle, are not my world. I didn't create them. As a child, I had big ideas and poor execution. My skill level has changed, rest assured. But I still remember the first time I got dressed as a witch, and I felt so empowered walking down the street as another being. Something in that process and appearance made me feel so powerful. I wonder, was that because it was a fully female character? Most of the monsters were male and they always attacked females. A man saved them. Witches were different. In the 70s, a sorcerer was a sorceress—often the evil one or the ugly one perhaps, but forever the powerful one.

There is a lot of freedom and diversity in the haunt industry. It's very attractive to women. I would venture to guess in the fourteen years I've been in the industry, from the home haunt for seven years and then Grey House Haunts, 75 to 80 percent of my cast has been female. Most women from my generation and previous ones were raised to not speak up. *Don't act crazy. Don't jump around. Cross your legs.* But when someone comes to my haunt to

be an actor, I tell her to "be really loud and do all the things that society, for generations, has commanded us not to do." (I only once casted a woman as a victim because I was trying to pull a silent girl out of her shell.) Then I make them aggressors.

Noticing how the women who work for me light up as they express themselves, ecstatic that no one is judging them, I wanted to know more from other female haunt owners. How they manage their houses, what traits and tools they capitalize on to make their businesses successful, creative techniques, future trends in customer service, and much more. What did I learn? These women are not afraid to slay!

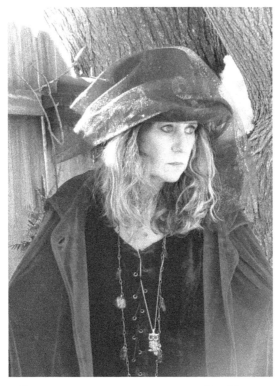

YOUR JOLLY DARK HOST AND AUTHOR, JAN KNUTH.

CHAPTER 1

INSIDE GREY HOUSE

*"People have discovered that they can fool the
devil; but they can't fool the neighbors."*

—FRANCIS BACON, FIGURATIVE PAINTER

THERE IS SOMETHING to be said for the notion that as we love the next movie villain, we also have an outlet to come out and be that very villain in a safe manner. In a haunt designed to be entertainment, you get to be terrifying and say creepy things without being truly horrible. We all have a dark and a light side so allowing that darker side to play a little is healthy and fun.

I was one of those people in my twenties and thirties who dressed up for Halloween and went out with whomever I was hanging out with at the time. Then Steve and I moved to town and we had two dogs that absolutely hated the doorbell. I didn't know how many trick-or-treaters there would be, so I decided to experiment outside. I made my sister, Jo, dress as a witch with me and we caused a little mayhem on this rare, beautiful October night, sixty-five degrees.

Jo, who is now my superb front-of-house manager recalls, "When you do it, you can't help but turn it into a passion. We always liked to dress up. That came from our mom and our neighbor who always dressed up. Our personality is funny and dark. It fit. Why wouldn't we dress as witches and threaten to boil children?"

To top it off, Jo's daughter, Shai, was trick-or-treating for her last year as "Snow Queen" before becoming my design assistant every year since. One quarter of all the candy sold annually in the U.S. is purchased for Halloween, and I've kept Shai's supply going in exchange for her mad creative and technical skills!

That year, we stayed outside all night hovering over a big flowerpot that "double, double, toil and trouble," we made into a cauldron. We had the best time talking with children and families. And not one doorbell rang to drive our dogs to a nervous breakdown!

The following year, eight of us dressed up and interacted, drawing the whole neighborhood to visit the yard. Then the next year, fifteen of us, like a whole cast of characters. Our improv den of sin grew and grew. We have a large lot, and the Halloween event encompassed the neighborhood basically, sending my husband for the hills. We turned the front yard into photo ops for smaller children and in the back, created a more elevated experience like jumps and scares and dares. The last year my event was a home haunt, 2013 in my yard, a fence was broken, and fake blood brazenly spattered my newly painted walls in the kitchen. The haunt became a big monster! We had twenty-six actors and 500 people had trampled through our yard in three hours.

I told Steve, I'm not sure what "this" is going to be next year, but it won't be at our home any longer. I didn't even know what that meant. He smiled, gritting his teeth and trying not to stare at the crime scene in the kitchen.

In March of 2014, I was trying to figure out how to proceed.

I knew I was going to do something to keep my spirited, spooky holiday alive. A real estate agent, who knew of the haunt, called and beamed, "Jan, I found a haunted house for you!"

Now, you always have to clarify—a house for capers on Halloween or a house that contains paranormal activity, demons and other entities? They're quite different.

She snapped, "For Halloween! You need to look at it."

I could feel my creative pulse jumping. Curiosity got the best of me. I looked at the property and thought, *I can work with this*! For our home haunt, we had to set up and tear down in the same day. It was exhausting and all-consuming. I didn't want to leave items out and didn't want to deal with weather incidents to destroy anything, which easily happens in Holdrege, Nebraska. We bought the eerie house. We bought it for the price of an average old car on the road right now. I was elated by the creative possibilities but definitely fearful of all the work ahead.

There were three and four feet of trash in any given area of this property, courtesy of a hoarder. It had been sitting there empty for at least two years. Feral cats had gotten in through a hole. I hired a company to empty the house. It was a mess. It still smells bad, years later. Cat urine in the wood. I didn't want to replace the floors because the floors add to the ambiance. Once, an actor walked in and huffed, "My room smells so bad!" and he sprayed air freshener. Air freshener in my haunt? The audacity. I didn't want to smell like "ocean breezes." We *pay* for nasty scents to permeate our rooms.

With this gigantic leap into directing a commercial haunt, there were many more considerations than the perfect scent.

For one, when I had hosted a home haunt on Halloween night in my yard, we were a bunch of volunteers. Some actors came with me to Grey House from the home haunt, and that was great. But they were no longer volunteers; now, I would be paying them. That also meant I would be a boss lady. That was

a difficult but necessary transition because I had to learn to hold someone accountable and reimburse her for the efforts. I can't have expectations of people I do not pay. This business exchange is vital to the transition to commercial haunt.

Also, regarding the industry, it is an art form. It's dark art. I didn't anticipate so many questions or blockades due to my gender. But then again, if I had clearly traced my need to be a powerful witch from time to time, I would have drawn the parallels and prepared myself a little more.

Men tend to be visible in the haunt industry not because men are dark, but it's acceptable for men to be into dark things. Prime example that I still get a kick out of: My husband carefully puts up a life-size nativity scene every year for Christmas and the locals thank me for that setup and then thank him for the haunt experience. They assume he has the interest in Halloween, and I love sweet baby Jesus. Every year, I tell you!

Over the course of the past seven years, there have been other offensive things. A guy in town created a pop-up haunt. These haunts literally pop up in a parking lot. It's none of my business who's popping what or where, but that season, Mr. Pop-Up had popped onto Facebook and other pages to mention Grey House. From his basic messaging, people assumed he owned Grey House. I had done years of the same marketing and now that a man was in the picture, someone want to recognize him and give him credit?

I've heard, "Women wouldn't do blood and guts!" Oh really? We are some scary creatures. That thought probably goes back to that nursery rhyme, "Sugar and spice and everything nice," or always behaving in a kind, demure way—not anymore.

Our opening night was October 29, 2014. We needed to make a splash, considering we were only going to be open three nights that year. How does one make a splash when two artic blasts roar in with a wind chill of ten degrees below? I was scared

to death. Partly because it wasn't only a new adventure, and I could fail. At the same time, the failure might have been really public. Well, the people came with great enthusiasm. When we opened the door, sixty people were already standing there patiently.

We had pulled in over a fifth of the population of our town from word of mouth, a newspaper ad and minimal social media. I think that was a pretty good start.

On the second night, you could hear these bangs, screams, laughter, a roar in the wind. I was standing behind the house where no one could see me. I thought, *we did it!* I found this house and made it into a haunted attraction! On this perfect, crisp fall night, the sounds carried incredibly, the fog rolled in over the garage. Grey House Haunts had shown itself.

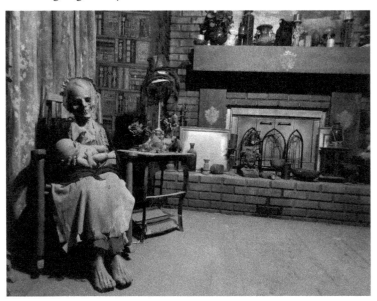

HOME IS WHERE THE HAUNT IS. ONE OF THE WELCOMING ROOMS AT GREY HOUSE HAUNTS IN HOLDREGE, NEBRASKA. PHOTO BY JO BREINIG

CHAPTER 2

WITCHES FLY

*"Don't part with your illusions. When they are gone,
you may still exist, but you have ceased to live."*

—MARK TWAIN, WRITER AND HUMORIST

IF YOU ARE among the population that cringed when I described the Goliath spider because it would be your worst nightmare to encounter one (or even a humble domestic spider), have you thought about why you are afraid? Have you dissected your fear? For those of us in the business of scaring and eliciting screams and laughs, we're not necessarily going that deep into the psychology of scaring. Instinct, sheer expression, creative genius, and some impulsiveness go far in acting and set design. However, I learned in the early days of Grey House Haunts that some knowledge and understanding of things like fear triggers and response does matter to the experience I strive to deliver to paying customers (or house guests).

The reason that "The Exorcist" (1973) still gets credited for being one of the scariest movies made is because it is unequivocally *scary*. The theme of possession had never been explored on

the big screen, let alone with such intensity, in the horror genre. The story follows one layer of madness after another. As a viewer, you're hit with disturbing sensory overload as the story progresses. What do you actually fear though? The content is inside a TV set or computer screen. It can't get you. Somehow your brain takes you to that place and situation being depicted, whether you realize it or not though. The special effects are realistic effects. I dare say that makeup artists Dick Smith and Rick Baker could compete with any rendition today, almost fifty years later. Last but not least, it's the authentic acting that brought the story to terrifying life. The acting was the key ingredient that made moviegoers pass out and run out of the theater. The viewers felt high anxiety.

Psychologists have identified fear as a basic emotion. According to Dr. Almira Vazdarjanova, associate professor in the Department of Pharmacology and Toxicology at Augusta University, fear is, in its simplest form, an emotion that enables human survival.

"Fear is a core emotion that's been preserved in humans as an adaptive response to a threatening environment and gives the organism the ability to survive," she said in *A.* magazine. "It enables survival." In a survival situation, fear is an emotion that can move someone to action in a way that is almost like a reflex, according to Dr. Bernard Davidson, associate professor in the Department of Psychiatry and Health Behavior at Augusta and a licensed psychologist.

"We have no choice in feeling fear," Davidson said. "Fear is healthy. It's good that we get scared when we are in a building and hear a fire alarm."

In many instances, however, people actually confuse fear with anxiety. When someone mentions they're scared of spiders, snakes or clowns, what they usually mean is that these things make them anxious.

"In its purest form, fear triggers a response to keep us alive," Davidson said. "Sometimes, we start responding to safe situations as problematic situations, and that's where we use the term *anxiety*."

Our goal at Grey House Haunts and likely others in the industry, as twisted as it sounds, is to trigger that anxiety. Just to be clear, some people have experienced real survival situations, whether it be a spider bite or a physical attack. I'm not encouraging them to deliberately live out these experiences again. I'm talking to the "anxious" crowd that psychologists have smartly defined for us!

How I have trained my actors to play on this anxiety involves more than you might expect.

As you see your audience, how you would scare them, a group is usually a group of six. Skip the first person because they're usually the brave one. The second through fifth are the ones you scare the most. The last one is the *anchor* and braver than the others. They're usually a parent or leader.

Female haunters are more likely to be the soul sucker. (This is all Jan talk!) Psychologically, this means they threaten your soul and your spirit. They won't punch you in the face. They're in clothing that flows. Males are likely to be in fitted clothing because they will kidnap you, beat you, kill you—they threaten your physical being.

They can mix, of course. You can have a female in tight clothing with a long cloak. She is perceived by the human mind as being a danger in more than one way.

We also take into consideration group psychology and dynamics, along with set design psychology. Set psychology is using color and lighting to direct the attention. The thing that is the lightest color is the route your eyes will take on in the room. Put the distraction in the lightest color and then have the actor come out of the shadows, out of their hiding place. There are high and low scares. People do not like you coming at their feet or from above. This is startling.

Someone reported me to the police once because my actors did their job of scaring all too well. Was someone more scared than you would have thought? My niece, Shai, has had grown men climb walls to get away from her. Then a group of teenage boys dropped to the floor to get away. One man thought he found the exit and it was her hiding place. He looked down and Shai was below him. He fell backwards and his whole group scattered. We joke that all she had to do in her haunt acting repertoire of gestures: Look up. The unsuspecting guest thought he was being smart by opening the curtain and there was this creepy creature. That was when the anchor of the group became the victim because he completely let down his guard. That was the *perfect scare.*

In the first year at Grey House, Shai would reset the room and close the door. The anchor would be the only one to hear and see her. She explained, "Some haunts swear to: Don't hit the first person. Don't hit the last one. Go after the soft pudding filling. But go after one of the tough guys. If you can scare them, you've really done your job. The customers form a little society at the door, and it has just fallen apart. Then they're praying for the rest of the haunt to make it through without a leader."

Channeling Anxiety

The impulse to scare was always in Brian and Scott Foreman's blood. They had a dummy tied to a rope one year from their father's two-story house. Brian went to a few houses in high school and never thought about acting or owning one. Then his brother invited Brian to do a haunted house with him on a campground, with thirteen old trailers, floors caving in. That sounds scary to me! Well, it was a volunteer position. That shut down, and then the brothers decided to do something on their

own. Scott had two acres in the back of his house, so they cleared out a trail and didn't know anything about the business. The city of Columbia wanted electrical outlet plans and $25,000 for these code improvements, prompting Brian to simply turn his garage into a home haunt for five years. This was a modest show, but he got to learn what to do on a budget and the role that actors play in scaring the living shit out of people.

Like almost every home haunt that grows, it got too big, and Brian's wife said, "You got to get the hell out of here!" Enter a friend's property and home to the wildly successful Dead Factory.

Each room in Dead Factory addresses a different phobia. There's a glow room, a vortex tunnel, snakes, dark mazes, torture, clowns, baby dolls, a swamp with a crocodile, large and small spiders, body parts, death and destruction. Some get changed up and switched out for new phobias every year. In sum, my friend, Brian Foreman, and his brother, Scott, based in Mexico, Missouri, cover the whole spectrum of phobias in case you need a reminder of what yours is. I refuse to state mine for fear of seeing it show up at Dead Factory!

According to Brian, the medical theme always stays the same, but each room allows the staff to change things up, and they have a 12,000 square foot building to indulge the madness.

We will talk more about story development in Chapter 3, but I want to credit Brian and crew for their medical-themed storyline that is fully thought through and acted. It revolves around a deranged neuroscientist called Dr. Phobia and his failed attempts. You walk into a reception room and the nurse is in a reception window and lets you in. She gives you a spiel about phobias. The four chairs vibrate, air shoots down, and a strobe light violates you, so they're trying to hit all your senses. Guests enter Dr. Phobia's room, and he lets you into a secret passage that represents his mind. Vortex tunnel, dark maze and a transition between each room that divides each phobia like clowns, spiders.

This is a seamless storyline until you see the exit sign, and it's beautifully executed.

I talked to Brian in-depth about women in the haunt industry, how they have played a role in his attraction and what his philosophy is about acting and scare psychology.

He said, "I've been in the industry since 2004 and so many women have helped me. I'm all about helping anybody. So many women out there don't know about each other. They bring a unique aspect. Half of my actors are women and not always the 'victim'. One girl has been with us for four years. She plays a butcher with chains, boots on. She's loud and effective. There are unique talents to everyone. They're not afraid to ask for advice or go outside the box. Our haunt was always lacking a haunt mom. Two years ago, she came in to fill roles and helped behind the scenes, picking up food, and run errands and then she became our haunt mom. Everyone knows Tory now. I've expanded beyond my limits and I really needed her last year. They help nurture the other actors. I look for that. Some guys take on that role, but not as many as women. People go to her because she has that ear. One actor had a breakdown, the ex who had abused her before, was coming to the haunt, and she didn't want to be in that room by herself. I would not have known this without Tory. We work on rotating actors, changing out rooms. I don't know what it is about women, but us guys… I think of myself as empathetic, but I don't see everything that a woman might. And I have been married twice; one, seven years, and the other, almost seventeen years."

As I mentioned, the first year I opened, we were only open three nights. In that short window, two of my female cast members had to run through the haunt to get to the restroom because they didn't plan ahead. Since then, I talk to all the actors—"have supplies with you, pay attention to these things." First-time haunters are nervous, and their bodies respond and react. With a

female, this type of thing happens, so having a mentor like Tory they can go to is beneficial. At the same time, Brian agreed that as haunt owners, we need to do our part to instill confidence in the actors, on a gender-neutral level playing field.

Brian added: "A lot of girls that come in bring a friend and I try to put them in the same area. We've had instances in the past where a girl was by herself. I try to have a male in the room next to them in case something goes down. A lot of girls have surprised me. And there is drama with younger ones. Don't have your cell-phones out. No Tic Tok! My goal in 2020 was to set up cameras. It's usually teenage boys or younger adults coming in. Guys will come and sit on the bed and make innuendos, suggestions to the actors. My girls have walkie-talkies with a direct line to me. A touch here or there—nothing to write up charges on—because by the time we hear about it, we have to find the guy. We have a twenty-five-minute haunt, so if something comes over the walkie, we try to stop the group, and then you have the bottleneck. I've tried to teach my staff about all the shades of sexual assault."

I was so glad to hear that Brian is a conscientious owner who has practices in place to ensure actor safety. The Dead Factory banks on Dr. Phobia's incredible storyline, but Brian is taking a strong stance on sexism.

I've had to recast an entire floor because I realized I put all girls in the basement. That even sounds creepy, doesn't it? I do rely on older female actors, too, because we tend to be more vocal. An eighteen-year-old girl may react differently, timidly, compared to a forty-year-old. I want them to feel safe, not vulnerable. They're supposed to be scary! We had a full-on assault before, believe it or not. A fifteen-year-old girl punched two actors in the face. There were bloody noses. She missed one actor and then went back and didn't miss. I had to escort her off the property. The actors did not want to press charges. Only 1 percent of guests do you have to watch all the time, but sometimes you can't possibly know who

will be among that 1 percent. Sometimes it's the dainty, unassuming ones that will cut ya.

I've spent a great deal of time on making Grey House very theatrical and actor-driven by providing quality training. Not all haunts can claim to have trained actors, and that is one component that makes us a professional outfit.

Training spans everything from safety, emergency evacuations, to the psychology of scaring and timing, physicality of scaring, rules. We don't touch people in my world. I don't think that is scary. It's offensive. We go through drills on acting. Improv classes become haunt acting. In my humble opinion, the more professional dramatic actor training they have, the worse the haunt actor they are. I tell my actors, when you are a real actor, you are emoting. They do cross over a little. You want people to feel what you are portraying. In haunt acting, I want to *make* you feel what I want you to feel. It's aggressive, almost authoritarian, and the other is, *come with me on this journey*. The haunt actor is not inviting you for a flowery experience that is open to interpretation. We want you petrified.

Sylvia Vicchuillo's Nightmare Nomads is a traveling scare actor troupe. Besides haunt acting, her team's mad skills range from snake charming, stilts and fire performance, to beauty and SFX makeup, comedy and dance.

"It's neat when you get a good crew," she said. "Working with actors is like herding cats. When you can get them to not scratch each other's eyes out, it's beautiful. I do miss being an actor manager. I loved new hires, going from shy to blossom the whole season. 'Got you! You're a haunter for life now.'"

Watching actors come out of their shells is amazing. One of the things I do in auditions is make them yell at me. I will not end the audition until they yell at me. I have to know they will do what I ask them to. I've always been afraid of my own voice, so I do it with them. We start this kind of maternal child bond because they feel that I will look out for them.

I know the yelling test can seem a bit nerve-racking. And sound, in and of itself, can be a contentious subject. You can talk to ten different haunters and they use sound differently. It's a preference. Certain sounds irritate human beings, or they may possess a phobia of loud noise. It is referred to as phonophobia, sonophobia, or ligyrophobia, and this condition is not caused by hearing loss, or any type of hearing disorder. Rare is the person who enjoys an incessant car alarm, or shrieking ambulance siren. Some loud noises, such as those made by fireworks, may be more easily tolerated since they're associated with pleasant things. Haunts can't be construed as pleasant…can they?

Regarding noise and other factors that go into the immersive experience, sometimes we think too much about the customer and not our staff. I have to remember that my actors are also human beings standing in a room for many hours and on many nights in a row. I ask how the lights and sounds will affect my actors.

One thing I do with actors that men in the industry may have to do but for a different reason is audition them solely to see if they will do what I tell them. I have had trouble with male actors not listening to me, so when I test their ability and willingness to take direction, I will not hesitate to dismiss them. I don't need the aggravation. Have I let a few good ones get away? Probably.

Sylvia has a lot of success stories. "One girl was a had-to-hire and for the first part of the season, I had her on the set with an experienced actor. It wasn't clicking. One night, I was short on a set of a clown series and every time I put a guy on the set, they couldn't do anything. And every time I put a girl on that set, they rocked it. So she rocked it as a twisted clown! Talk about amazing twists. She needed the right fit to be a great scare actress. She had long hair for pigtails and teased it to the hilt. She was horrifying with crazy eyes. 'Tell me I'm pretty!' She was doing it too well."

Something has been gnawing at me during the course of writing this book, so I talked to Sylvia about it. A person I

interviewed responded that we "need to teach our younger women to pull themselves up and that we are coddling them." In the haunt industry, is it our perception holding us down rather than the reality of the discrimination?

Sylvia offered: "There is still an old boys' mentality. I wanted to have a male come down and have a clinic and he had the audacity to say, will there be girls for me? Up until that point, I really admired this person. I will encourage and tell them to fight their fight. Know that there is a safe space. It's my duty to pay it forward. If you're on the bridge holding the rope, they need to do something for themselves. I'm fifty-six years old. Are you holding me back by doing the same pattern? I will throw a rope always. Am I getting dark? You're fighting pre-conceived notions. I am meeting more women that are owners, actor-managers, costume designers, and world-class makeup artists. Some are really rising to a different level of talent and stardom. Growing up in Central Florida, we were commanded to get married and raise a family. This is not the thing drummed into your brain with this generation. They can pursue their dream."

I can relate. I have a detective mind. I can solve mysteries and made a comment about being a cop in a former life. My niece, in her twenties, asked me why I didn't become a cop. I paused for a minute and informed her that in 1983, it wasn't really an option in rural Nebraska. It is an option now. One of my security staff, an off-duty police officer, was a female, and I was proud to see her in action.

Sylvia added: "Females I know now are swinging the door wide open. Caisey Cole is living her life and fulfilling her dream, making her life complete. Girls today are not buying into the same limiting thought patterns."

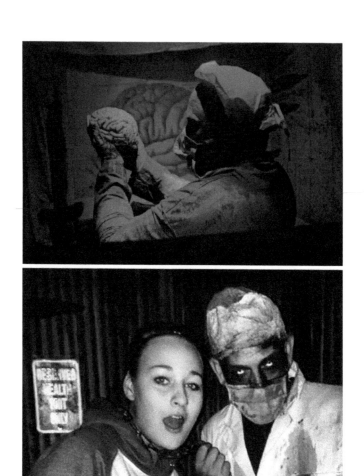

Brian Foreman's brainchild, Dr. Phobia, at The Dead Factory in Mexico, Missouri. Photos by Tori Erwin

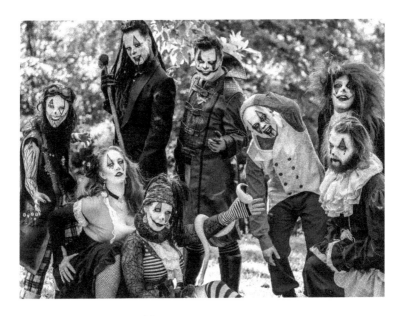

Nightmare Nomads bringing your nightmare to life. Photo by Blanchard Williams

Slayer's Wisdom

Caisey Cole on Haunt Acting, Identity and Pushing Boundaries

I attribute my haunt acting to Sylvia Vicchiullo. I was always interested, and my friends worked for Halloween Horror Nights at Universal Studios. I did a show with a mutual friend and Sylvia told me about A Petrified Forest. I auditioned and I never saw myself as a scary person. But kind of an alternative person. My friends and I were into scene styles, goth styles, as a kid and enjoyed the aesthetics of it. Being in the haunt, I got to express more of my scary ideas. The musical I worked with was "Carrie" so that helped! They were looking for actors who could be scary. It had a short run on Broadway, but that's where we met up.

I've always said that comedy and horror are like cousins, maybe even brother and sister. Especially if you think about Jordan Peele, who came from comedy and then put together all-star horror films. The clown moved from one genre to another. Clowning has history dating back to *commedia dell'arte* [an early form of professional theatre, originating from Italy, that was popular in Europe from the 16th to the 18th century]. And the way you move your body can be clowning and adding to your ego and giving yourself that extra *oomp*. In Peele's movies, people are being clowns, a different version of themselves, which may not be seen often and might not be acceptable to common society. I'm taking the side of this as a career and taking this rather seriously. A lot of us don't do that, and that's okay.

Clowns can come out in everyday life, and I'm actually an introverted person so I don't do that. I don't bring my scary self out often. It's a little demon, and I love my demon. I think she is cute and terrifying because she is so small. I have a small stature, 5 feet and 100 pounds, but I still make grown men run away. I've always had a small footfall. This training needs to embrace who you are as you come into the room.

If you have seen "Us," you don't think that woman can be scary and then she pulls that out of her—this is a lot of vocal training and good ways of standing still knowing your body and knowing what you have when you walk in the room and how to manipulate that, so someone gets unsettled because you're the opposite of what they expect from you. No one expects me to come at them with a weapon or move quickly, but I use that to my advantage.

In haunts, sometimes they have to rely on certain sides of themselves to the point of draining. I'm not sure there is a right and wrong way though because there are so many ways to scare someone else. There is a power in using what I have without a lot of enhancements. I want to challenge myself. How scary can

I actually be to these folks? I used a bath towel and a little bit of blood and used the rest of me, that's it.

A solid acting method? Start from within. Start where you are at and go from there. I have done a lot of work in children's theatre and they will call you out if you are fake. They will not hesitate. Embracing circumstances you're in makes it easier for you to find a way to embrace your scary style.

I've been assigned as a swing multiple times. I played two characters in this last haunt I did. I find them queen of their territory. I played a victim twice. I was tied up as a Rapunzel and the audience had the task of helping me, which is scary for them. They won't win at the end of the day, and that is the goal in haunts. As a woman of color, in the sake of nuance, since I have five years of experience, a lot of folks have trusted me to put on the costume and go as General, Victim, Intermediate, the Lure, the Distraction, and I find a lot of power in knowing what I want to be that day. Becoming the captain and putting on an alter ego. I'm not a huge leader in everyday life even though people put me in the role.

It's fun to scare a huge man and as long as I don't break anything, I can do what I want in my own room. Tall people don't like things underfoot. If they are short, they don't like things above. But I can do both. Having that flexibility and creative nature is so liberating. I don't think it matters in whether you are victim or perpetrator because you still know how the story goes. They don't know. Same goes for theatre. You have the power to create the narrative. The position is so liberating. At theme parks, where the customer is right, the haunt attitude comes along and says, not really. It's liberating because I have been a swing in two theatrical shows and otherwise, I am in my head a lot. You don't have to worry if you are adjusting to new gear, new makeup and you can switch up your gear anytime. I've studied classical Shakespeare improv. I'm a huge fan of being a swing because you never know what will happen next.

I'm the type to get bored really quick. By the end of the night, I can't do the same scare. Every time my director came through to check on stuff, I would be doing something different. He loved it. It was a new story in my head. I've done "Polar Express," and they need utility players for that, too. Every actor should learn how to be a utility player even if it's not their strong suit.

I love haunt families, but I'm also very introverted. I'm here to get my money for tonight and to scare people. With my upbringing, the haunt society is pretty welcoming in Orlando, which is diverse. I'm primarily Caribbean. It has a mix. Then I came to Kentucky and it's not the case. I'm not concerned with being one of the only people of color in my haunt. My experience may be different from others. I wish there were more Black women and they felt comfortable enough because there is a sense of power from it. Some people wonder, what if I'm not scary enough? What if I just don't get the gig? I have found a family with it though and I have power within my space, which is so helpful. I have a domain. It will come more from movies like "Get Out" and "Us." They say that "Candyman" caused a surge back in the day, and it's coming back. Seeing the capabilities to be scary go beyond racial trauma, victimhood. A lot of people of color are afraid of being stereotyped and put into a thing that will stereotype them. The haunt is such a collaborative, grassroots thing so if someone is experiencing discomfort, it's listened to, acquiesced and addressed. This doesn't happen in every industry. As a person of color, I would enjoy more advertising toward that.

A lot of spooky aesthetics are coming into view. Rico Nasty, Beyoncé, and Rihanna are doing Southern gothic, scary stuff and I love it. Personally, we love it when the Black folk come in because they are some of the most responsive. That is a stereotype that I will take because it's people enjoying art. They will come in and react to me. They will try to have whole conversations about it. They clock that I am Black so quickly and so readily. I hope

my face out there is more of a signal to say, 'Hey, go, audition, they need specific talent'. A lot of Black alternative people I know do tarot, witchery. They love their spookiness. Even though you would look at me and see a commercial woman, not punk, I love those arenas. A haunt is a good way to express all this. Differently abled people found something they delighted in and made themselves visible. For Black women, their fears are already reflected in everyday life. Reversing that and having even a month in which to do it is vital. It changes us because we have power to scare others and with minimal makeup. I love it every time.

CAISEY COLE REVELING IN HER SCARINESS.
PHOTOS BY TWILIGHT PHOTOGRAPHY

allow a gum wrapper on my floor because it's post-Civil War. Some people say I'm very picky.

I know Sue Gray is, too. She's the owner of Graystone Haunted Manor in Longview, Texas, which opened in 2011. As of this writing, I congratulate her on a decade of devilish success!

Remember I called haunt owners storytellers first and foremost? Sue became the quintessential storyteller in the third grade and grew her craft to become a bona fide haunt park.

As she tells it, "I created a bloody scary green hand out of an old white glove of my mothers. I carefully hid this scary green bloody glove under my jacket as I walked to school. When I got to school, I immediately headed to the girls bathroom and placed this bloody green stuffed glove into the paper towel dispenser so my victim, who would eventually enter, would see this horrible sight sticking halfway out of the dispenser. And then it happened. My very first scream of terror from a fellow classmate. I was hooked. As I grew up, I had many Halloween parties where I would create creepy sets and props. Everyone seemed to love my creations. I have always been pretty artistic and creative, so all of this did suit me. I eventually, for several years, decorated my local art museum during the Halloween season. Many mentioned to me that I might start my own haunt for others to enjoy so I decided to go all in and open my first haunted house in 2011. I began to build for two full years before I opened Graystone Haunted Manor. During this time, I did a ton of research. I got on every haunt forum I could. I attended TransWorld several years before I opened Graystone. I remember the very first night we opened, I was still screwing in boards when the first person bought the first ticket and as she entered let out the very first scream. I have not looked back since."

Sue, "A+" for preparation, determination and execution! She also has the best replica of a cemetery that I have ever stumbled in. You can see how the old black and white horror films that she loves

CHAPTER 3

LIPSTICK ON A PUMPKIN

*"There is no greater agony than bearing
an untold story inside you."*

—*MAYA ANGELOU,*
POET, MEMOIRIST, AND CIVIL RIGHTS ACTIVIST

I GET A LOT of questions about the house that is Grey House Haunts. Was it already primed for a haunted attraction? Well, remember that someone once lived there. Though it may have had a creepiness factor, it wasn't a haunted anything before it became my labor of love.

The first couple of years were getting the spaces made. Get the staircase in. Make the blank slate for each room. Then we based it off the direction that the customers are coming in. Direction dictates where the scare can come from, where the entrance and exit are for the actor, and we base our design around that. We use the design to focus our attention, our storyline, not just making it look cool.

We tell people our goal is scaring people, but we're actually storytellers. It should be entertaining people rather than just scaring. I've owned a commercial haunt for seven years and I won't

influences her sets. She also strives for the detail of haunts like 13th Gate in Baton Rouge, Louisiana. I absolutely need to state here that 13th Gate's promotional trailers rival those of any horror movie. Top-notch evil genius. If I could package up their videos and drop them in this book to spring out at you with a video player, I would.

"For me, the scary part of an experience is the unknown. What is around the next corner? It is the whole package, set design, props, actors, music, and smells. I want all my customers to feel like they have been in whatever set I put them in. I pay great attention to detail. Many of my customers have asked if my cemetery is a real cemetery. That is what I am looking for. My motto is: *Give each customer their money's worth.* Value is extremely important to me. I do not want anyone walking away feeling like they did not get what they paid for. Graystone is a haunt park; we have five different haunts all for one price. We have a midway that offers axe throwing, a magic show, gift shop, museum, outdoor movies and a bistro."

I love the extended experience that Sue has created with her haunt park. How utterly brilliant.

When I talked to fellow haunters like Sue and Brian and those in complementary roles like Sylvia, I found myself entranced by even their personal stories of early Halloweeny leanings. (Someone, please bring me the cookies and milk, and settle in!) Their stories are also infused in how they function and flourish in this industry.

Sylvia Vicchiullo was the very first person I said I wanted in the book because of her take on acting and storytelling. When I met her on a video call, she snapped a fan like no one's business. "I owe that credit to the girls and the gays," she quipped.

She shared that she grew up on a horse farm and in high school, her mother thought she was too shy, so they put her in a local theatre group, a children's theatre in Orlando. Eight years ago, a friend was doing a local haunted trail and had lost their

stage manager. Sylvia began working with A Petrified Forest, courtesy of owners Trish Smith and Kim Clark, who gave her a chance though she didn't have the background. She always enjoyed Halloween but getting behind the scenes lit a fire. Sylvia attended Midwest Haunters Convention in Ohio and met other haunters and realized there were other people who had a drive, a love of all things spooky.

When she had the itch to learn more and explore the haunt map, Sylvia checked out a different haunted house every weekend in Michigan, South Carolina, and Louisiana. She pumped her newfound knowledge into the Nightmare Nomads. The troupe has performed at Deceased Farm in South Carolina, Scream Hollow in Austin, an outdoor farm, Lake Joy Trails of Terror in Georgia, along with the old Putnam County Prison for their Valentine's event, one of her favorite walk-throughs ever.

The No. 1 teaching Sylvia hands down to her actors: Story! Story as safe entertainment. "Our ultimate goal is for everyone to scream and laugh. John Laflamboy of Zombie Army Productions was putting on a seminar. He said, 'We're entertainers. If you don't scare them, make them laugh.' It's true. It gave me freedom to step back and realize not everyone has to be scared all the time. You want it like a roller coaster. Scare them and then lull them back into security."

I explain to the actors, "Jane" is the medium and "Joanne" is the big scare. If it's all big scare, they become numb. Most actors want to be the big scare. Then you have a utility player, who is that person to take tickets, monitor the exit. The utility player is setting them up.

Sylvia added: "I worked so hard at A Petrified Forest to do what you are saying, and train properly around that concept. My last year there, I was a proud mom in the walkthrough. My actress was doing 'Scary Tales' and I was coming onto the Rapunzel and Old Mother Hubbard's set and Old Mother Hubbard was laughing hysterically. The girl on the Rapunzel set scared them so hard that they ran right into the castle. She said, 'I had to bite my cheeks in

order to scare them as they came into my set.' The actor was talking about another performer doing so well, and I was so pleased that the team concept was front and center. That was a shiver on the arm because I had explained the whole time that everyone was important. I call the medium thing a creeper. My son is good at this. We had an Egyptian scene and there was no way to get a good scare in there. He and this other guy would wear robes and chant. Ambiance set. The guests were still affected."

Haunt Shirts owner Melissa Winton concurs. "Fear is such a personal and subjective thing. My childhood wasn't all sunshine and flowers, and since I've met real monsters in my life, it's hard to scare me. It's almost impossible. You can startle me. What I used to teach people was the more it makes sense, the more people can suspend disbelief. If I am going to a haunt that is a Victorian manor, there shouldn't be clowns in it. I know why haunts do it—you get a reaction from chainsaws, clowns, zombies. But that is a small section of people you are trying to entertain. It needs to be a cohesive story. Think of it like a movie. If it's all about vampires, you're not going to suddenly see a zombie or clown. In Zombieland, the guy was scared of clowns, so a freaking zombie clown coming after his ass. He was a zombie and happened to die as a clown. If you are going to immerse people in it, make it all make sense. Don't shock them out of the world. One haunt started out in a manor, then a hospital, boiler room, there was no connecting point. The haunt needs flow, story."

One thing I talk about in the whole build season is, keep them in our world. Again, no gum wrappers, or anything that stands out. Three seasons ago, we were done with the season and shutting the place down. I looked at the desk, our main character's office, and there were glue sticks sitting there that had been all season. Usually, we're so careful. I have other people walk through. Make sure there isn't a water bottle or screwdriver. I work really hard at that theatrical experience and keeping them *there*.

Melissa added: "I was at one haunt in a strip mall, and you could see the ceiling tiles. White. They didn't paint them black. I was so busy looking at the damn ceiling tiles, it was jarring."

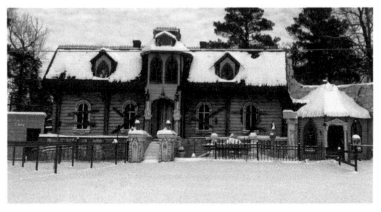

GRAYSTONE HAUNTED MANOR, OWNED AND OPERATED BY SUE GRAY, SITTING PRETTY IN LONGVIEW, TEXAS.

MELISSA WINTON AND A CREEPY FRIEND SPORTING ONE OF HER HAUNT SHIRTS. PHOTO BY JAMES WINTON

WHERE CREEPY CONTENT GROWS

Prolific storyteller Scott Swenson advocates suspension of disbelief above all, as haunting is a form of theatre. You walk through it and the moment you see a wire or light fixture, you're not believing anymore. Haunting is taking what you have and making the best out of it.

"I've told people, give me five good actors and a candle, and I can scare the crap out of you," he said. "I've always been a big chicken when it came to haunted attractions and haunted houses. I've learned more from being scared than actually creating for people, so I create from that place of fear that I know I once had."

When Scott was seven years old, he went into his first haunted attraction and learned that using nail polish for blood is a very bad idea, especially on your face. Twenty years ago, while working at Busch Gardens as a manager in the entertainment department, Scott was selected to be part of a team to leave their jobs for six months and put together a 'shoulder season' theme park event. Being in Florida, they were trying to shy away from Halloween since Universal Studios largely owns the Halloween season in Florida theme parks. The group checked out any theme park that did haunted attractions and attended the mid-year Global Halloween Convergence of independent haunters and home haunters, put on by Rochelle Santa Polo, who used to be the owner of *Halloween* magazine, which no longer exists.

Ultimately, Scott and company put on Howl-O-Scream, a complex consisting of haunted houses, scare zones, and live entertainment, at Busch Gardens, in 2000. For fifteen years, Scott acted as creative lead before striking out on his own with Scott Swenson Creative Development. Since, he's directed the Vault of Souls in Tampa, helped to create Dark in Fort Edmonton in Alberta, Canada, Creatures of the Night in Zoo Tampa, Undead in the Water on the American Victory Ship, a World War II cargo

vessel, and loads more events, with enough content in his head to write two books and form the podcast, Scott in the Dark. He has listeners all over the world and is part of the Haunted Attraction Network.

Of creating stellar stories, whether you're operating a happy home haunt or a mega complex, Scott advises, "It is essential that every haunted attraction has a beginning, middle and end. It follows the basics of story. If you're doing truly immersive, which is nonlinear, like Sleep No More, you still have the basics, but the storyline is complex because you have a lot of characters. In creating immersive worlds, I coined the phrase 'story sphere' because with a linear experience, you have a storyline, which has exposition, a beginning, rising action, climax, then following action. A story sphere is exactly that except it follows all these different characters from beginning to end. Where you decide to jump to another character, it moves you forward. I use the example of if you walk down the stairs on Christmas morning, and you see this beautiful tree, the first thing you see is all these beautiful twinkling lights, but if you didn't have this strong, beautiful Christmas tree, it would just be boxes of bobbles. I think of the story as the Christmas tree. If you have a great story, you can use it as a litmus test for all the great things you want to add. If I go to a trade show and see this great animation, I wonder how I can change the story, so this animation fits and enhances. Don't just randomly put it in there because it looks like a warehouse without cohesive narrative."

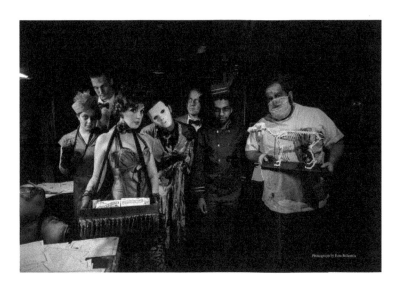

Created by Scott Swenson (top L), the Vault of Souls in Tampa fuses elegance with the paranormal to take guests on a hell journey. Photo by Foto Bohemia

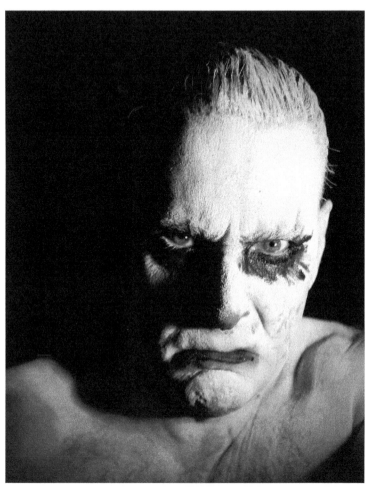

Sotto Voce, the clown with a taste for human flesh. Created and played by Scott Swenson

CHAPTER 4

PERFECTLY WIRED WOMEN

"Love is a fire. But whether it is going to warm your hearth or burn down your house, you can never tell."

—*JOAN CRAWFORD,*
ACTRESS AND DANCER

CTORS, STORYTELLING, AND *construction*, oh my! This is where my readers may react either favorably or shut their eyes with boredom for a little while, thinking I will feed them a Home Depot catalog. It's a great time to cue up a stat, like: According to Slice Intelligence, in 2019, women accounted for 45 percent of Home Depot's online sales and 47 percent of Lowe's online sales over the course of 12 months. Also, competitor Wayfair drove 68 percent of its sales from women.

I'm not a pro fabricator like "The Halloween Lady" Jes Murphy (who will be featured soon), but I'm a pretty good builder. I possess better tools than my husband by far! I might not be able to lift a humongous panel by myself, but I'm perfectly capable of asking for help.

I start conceiving each show in January. In a normal year,

starting November 1, I'm just eager to recover. I almost always have a physical injury by that point, which needs to be tended to! I have assistants. Jo on managing and Shai on design and building. The marketing, training, operations is all on me. I try not to think about the next show until January, wondering if I can tear a wall out or design a set. I'm waking up. What I do in January may never come to fruition, but at least my mind is moving with ideas of the macabre and sensational. These ideas tend to fly at me from all directions. Every haunt—and there are about 1,500 haunted attractions in the US, included theme park events—contains an element that appeals to another haunter. I went through one in St. Louis a couple of years ago, and I was amazed at every turn. I took some ideas from them. There are really no "original" haunts. You've got to make it your own somehow. Movies and more recently, epic TV shows can also be inspiring. I love "Walking Dead" because it's the perfect world that revolves around the human condition—with monsters. You see what both relational and isolated humans are capable of, good and bad.

Some haunted attractions may have a bigger staff, including a manager. Me? I'm a director of twenty-six one-act plays that happen simultaneously! Needless to say, it is quite tedious to hide in what I call my "hidey holes" in full costume. I can barely get inside with a tool pack or flashlight, and I always want to be accessible to my staff. The actors keep threatening to put one of those pedometers on me. I walk miles and miles. I might be terrified if I knew the number of miles. We have four sets of stairs and I'm up and down all night. I check on the actors. I follow groups through to see how the actors are doing. I'll get a call about a curtain falling down, so I have to sneak in with my trusty stapler.

The first year Grey House Haunts was open, a really successful room was all white (which I know goes against imagined traditional haunting rules), and I had a character that came through a slit and blindsided guests. Well, her curtain was coming down.

Without that sheet, she could do nothing. I looked at the sheet and I was behind in the actor hiding spot with her. She said, "How do I get through?" I half-whispered, half-screamed, "Just go!" I stood there holding the sheet in place. I took the gum out of my mouth and stuck it on the frame and pulled that curtain on it, then made my way all the way to my work room, retrieved a tool and returned after the gum had held it up for several groups to go through.

Actors have war stories every night. There are injuries and most have been minor. Not watching where you're going in the dark can lead to a lot of bruises! I've instructed the actors never to go backwards through a haunted house. In my home haunt, an actor had chased people backwards and he got annoyed when I demanded that he stop. Maybe he would understand if I could've explained: When we're closed for the evening, I get behind the last group of customers and tell my actors it's time to close and they get behind me like little ducklings, so they can get out of the house without ruining the last group's scare. It's very coordinated. My first actor in the door doesn't have to stand there and wait for the group to get all the way through, and they don't hit the break room at the same time.

This particular night, one actor had chased that last group of customers but then ran backwards through the haunt. I came to a curtain as he came through it and he knocked me out. Don't go backwards through a haunted house! I was going in the right direction. He was not. My very own "war story" and concussion.

There are different groups and subdivisions in the haunt world: owners, actors, vendors, makeup artists. Most of us call ourselves "haunters." When it came to building, wiring and digitizing…well, anything, I watched a lot of YouTube learning techniques over the course of many hours and late nights. How do I make my job easier and more efficient? Spend less money and scare brilliantly? I could learn at my own pace and save additional questions for the relevant discussion groups.

Back then, discussion groups were hopping…and I have to say, it was like walking into a men's locker room! Perhaps one other woman was in and out of this board. I thought of myself as the thread killer before she showed up. I was the one woman on some of these threads and as soon as I would say something, the thread would stop. People would message me and give me advice, but not in the general thread of haunt owners. I suspect there were other women in that discussion group that couldn't be traced to a specific identity, but they weren't speaking. I kept trying to kick this door in. There would be this long thread of men talking and exchanging ideas. I would say something, and the thread would die. Maybe it was sexism or newbie-ism. I will probably never know.

My adorable husband suggested I make a new profile as a man, and I said, emphatically, "NO!" Then I would just get more pissed off that I had to do that. Steve said, "Is your picture on your profile? Put your picture up." *Hell no!* I'll stay a werewolf or a witch. He said, "But you're pretty and they will respond." So, my dearest husband was playing right into the problem. I want business advice and proper networking—not attention for being a woman who someone may find attractive. I have to put on lipstick to solicit info from my industry?

I *own* Grey House. I run my haunted house and the decisions around it. Steve has been mistaken as the owner. The first year, I needed to add a stairwell because you can't have groups using the same access. I called a contractor for a quote. I wanted it built on the outside of the house, which I found was way beyond my means. I showed the man what I wanted, and he turned to Steve, just around leaning on a trailer, and started talking to him about it. I may have waited all but fifteen seconds and stated, "Since I'm the one writing the check, you probably should be talking to me." He didn't get the job.

Melissa Winton informed me that many women have contacted her to say, "You are such an inspiration for conducting

workshops at TransWorld!"—meaning, that Melissa was a rarity in the instruction of construction. She has been building for twenty years, so it blew her away to know there are so many women out there not getting recognition. Women are also guilty of this, thinking the power tools belong to the guys. She would be the first one to do a honey-do list before her husband, she insisted. We both agree that there is this weird stigma that if there is a power tool around, it has to be operated by a man.

She explained, "My husband did not know how to work a drill. They scared him. In the theatre industry, I liked to build the sets, not act, and I was not taken seriously. I go to Home Depot all the time. They know me in the paint department and lumber department. I could go there three times a day in the middle of a build. When I was building for Crafted, I was loading all this lumber and this man came right over, physically taking the wood from me, as if to say, 'Honey I have this. You need my strength, you need my help!' No, thank you, I would ask if I didn't have it. In my studio, there are huge 4 X 8 tables that weigh like 600 pounds. I put them on castors so I can move them. There was a birthday party, and I was teaching kids how to do signs. This man was completely barreling over my instructions, telling his kids other things that made their results pretty average compared to the others. I was going to do a demonstration and went to push the table, again, on a castor, and this man leaned in and said, 'I got it!' He didn't realize that it would move so effortlessly and put all his strength into it, pushing the table and fracturing my foot."

I heard this story and it floored me. This man didn't know how to handle the equipment. Melissa did, and she got hurt for it. Outrageous.

It reminded me of the time that a man said our haunt tried to "destroy" his haunt. This guy was known for not being nice to women. His haunt was gore and took up a parking lot. Someone, or the wind, stripped down his plastic. I would never allow any

kind of tampering or even speaking poorly about others in the industry. He stated in a Facebook video that we did this and that I told my staff to write bad reviews and tear up his sets. He accused me of a crime. He edited the video to remove my name, but still said "the owner of Grey House." That was very disappointing.

I asked Melissa how she became so handy in the haunt world, then silently wondered if she would ever come to work for me, but no chance. She was returning to the law industry the same week that we spoke.

"In Orlando, I came from a theatre background, major in college, and I went back to get a BA in literature. An aunt worked for Disney. A cousin worked at Universal. I could go anytime I wanted. I must have gone forty or fifty times. In my sophomore year, I helped build a set for 'Hello Dolly'. I fell in love with it. I was meeting with the Imagineers who built the rides and how they made foam look like stone. My parents were home haunters. I was nine and they used to build a tiki hut and my stepfather dressed like a witch doctor and scared the kids. Fast-forward to a full-blown legal career and then when I had kids, I left it. Then I got back involved in arts and Halloween came around. I decided to build something for the front porch to scare kids, and it got bigger and bigger for the garage. I posted pictures and how-to of each piece on Facebook. Then I got introduced to Haunter's Hangout by Jwal Walden, so I interacted there.

"One day, with a prop I was having a hard time with, I posted, 'I am Hauntzilla! I will beat you!' The prop was my version of Azrael, Angel of Death. I was featured on Haunter's Hangout four times because of sharing that prop. TransWorld asked me to teach distressing techniques and scenic design. I taught at several conventions. When I started my business, they wanted me to do classes on starting a haunt business. Then I dragged my husband into it. At TransWorld one year, we were walking around, and he said, 'Nobody is selling shirts!' He had always wanted to do

a T-shirt business. Then Haunt Shirts steamrolled into what it is today. We got a bit of backlash on the coronavirus T-shirts, so we did one run and that was it!"

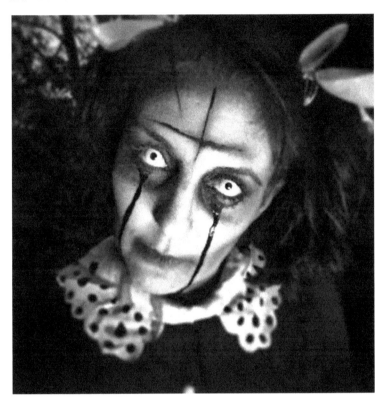

MELISSA WINTON REMINDING ME OF THE SCARIEST MOVIE EVER MADE. PHOTO BY JAMES WINTON

MYTHS ABOUT MONSTER HOMES

I don't think a lot of people realize how highly regulated we are, and this is where all things construction and tech come in. The regulations and requirements for haunted houses may differ in each state, but fire marshals and city ordinances are no joke. In Nebraska, Grey House Haunts is inspected twice a year. I had to

install non-skid tape on all my steps, exit signs, alarms, emergency lighting, sprinkler systems. It costs thousands of dollars to direct an indoor haunt. That is more than the actual house cost. In addition, almost no haunt owners make a ton of money. It's like the old adage about the country in general; "the 1 percent" and then "the rest of us." The 1 percent may employ forty or fifty actors.

Allen Hopps, a renowned industry veteran, says the 70/30 actor ratio for women in the haunt industry is not as represented in ownership, except for couples, let alone in building and tech. "In husband-wife teams and like in many things, women tend to take over administrative duties, and I'm not saying right or wrong. Men may come over to my booth and say, 'I want this, that, two or three of these, let me have my wife cut you a check.' Women are responsible in that sense, which I don't necessarily disagree with. It's more interest than discrimination. Why aren't there more female scientists? They may not be steered in that direction. When they are younger, they assume it will be a certain way. Dark Hour is owned by Lucy Moore, a single woman. I may be the voice of the show, but I don't own it. She wants to put on a great haunted house, and she hired me to do so. Lucy is an introvert and enjoys seeing the haunted house happen." (Stay tuned for more from Allen a little later.)

SLAYER'S WISDOM

Jes Murphy on Improving Your Tech-Savvy Skills

I have crazy mad fabricating skills, and I'm always willing to share tips. We are working on inventory from two trailers over the winter. We own a trucking company. I am spoiled. My husband sells trailers so every once in a while, we will buy one and rehab it.

I always loved Halloween. I was a goth in high school, always wore black, the only one, then it was cool to discover other crazy

people who love Halloween, the aesthetics, and how to make things. I was the only girl in high school taking tech classes. Running the table saw. I own an iron and an ironing board, but it is on the back of the door. I've never used said implements. I grew up in a state park and my dad was the park ranger. I grew up surrounded by nature with several thousand acres of playground. Our house was on the stream that led to Bash Bish Falls, which is a semi-famous tourist attraction. I could rock-hop or take one of a dozen trails and never hit asphalt. Being the 80s and a park, I learned how to plunge a toilet, fix a door because that's what Dad was into.

I have a ton of crafts and supplies in my entire garage and basement. When I got older, I realized that crafting didn't have to be glue and felt, sewing. I could build stuff but building cool stuff doesn't necessarily make money. I was flipping properties and had my own construction crew. I was one of the lucky ones that got out before the bubble burst. My guys and I didn't have giant loans. It was terrible here. I went into bookkeeping, but I had all these tools and abilities to use these. The decision to turn the basement into a haunted house was made that September.

My biggest collection of decorations was always Halloween stuff, like six times as much! We moved into this big house and had this great big open basement. One of my crew was retired and bored, and that is how I morphed into what I do now. We built panels in September and it grew from there. I decided to do it themed. Grimm's Grimmest Fairy Tales. I ran around losing my mind on Craig's List picking out stuff that fit the theme. A spinning wheel, which I hooked a motor to, that had a thread going under it for Rumpelstiltskin. Little Red Riding Hood and the Wolf. I took apart one of these hopping spiders, took all of the fuzzy off of it, rewired the lights so they were sticking through a skull and made it sit down into this bed. I carved a bed out of foam instead of a mattress, set the mechanism down in so that when

people came through, they stepped on the little scatter rug on the floor in grandma's house and her head came up flying at you with glowing eyes. Then we had a spider for Little Ms. Muffet.

The year before, we had a Halloween Housewarming Party because we had only been in the house a couple weeks before Halloween, so everyone wore costumes. Everybody loved the party that year. We had thirty people. Then "haunted house" the next year, I told everyone once I made the decision. We had about fifty people. They thought it was spectacular, but I thought it was *simple*. It took five minutes or so to walk through. Some of the older crowd are the best reactors. They scream at anything and this makes it better for everyone else. The next year, I thought about the basement and not having other exits and having extension cords all over. I could do this better and safer. I thought of doing a tent, a party outside with heaters. I laid out my plan so every area had access to an outside wall, a center corridor where people could hide and then come out. We had 100-125 people. Last year, a third year with the haunt, we were at 200, just people we know and random waitresses who worked at restaurants everyone ate at the night before, and the firehouse guys who I work with.

I do a different floor plan and a different theme every year. I am very organized. I know the next five themes. When we decide to build a prop, or make a scene, how does this translate into the next five? Can we resell the parts? We did Sweeny Todd, and I had a real barber chair that was 250 pounds. It made the scene. It had a handle that tipped the chair back. We had to take it apart with help from 'the herd' and they had to get this thing across the lawn. Meaning my husband and his friends. Last year, everyone was into it. The majority of the props we build and create. We start costume stuff in January, February, March. We call them the 'boo crew'.

I have worksheets I do for a new prop. Quick description of what room it's in, drawing on how to use and how to create this item. I know how much space it should take up and there is an

empty tote to put the materials in. My crew is all women. We have two guys and my husband. Joe is my right hand for building. Last year, we did add guys. We have three generations of women into this. I'm a one-woman show. There isn't a lot going on in our area for haunts. The firehouse put it on as all guys and didn't last more than two years, but it wasn't intentional. I was a Viking last year and the straps were supposed to be pinned. My pins got lost so I wired them up before showtime. Most of the comments were from girls, that I could have tried harder. Really? Everyone is a volunteer. You won't volunteer for a chick if you can't take orders from a chick.

What inspires the themes and props? Sometimes it's a cool idea. I have 100 carved pumpkins. Clowns. We work it on our Pinterest board. Carnival can be a theme for the year after. We have a segment this year now, but next, it will be bigger. Outdoor carnival theme. It's the progression of one thing leading to another. Last year, it was my mother's seventieth birthday, so our theme was Vikings. We are Scandinavian. We celebrated our birthdays in Sweden. She was 'Hell', so she had a beautiful half-face. Wicker chair with big round back that you see in every 1980s bridal shower. I got this sequined shimmery fabric for the back, and I took a piece of corrugated ridge pipe and then leather-wrapped it. She was the Queen of Hell and these three dragon heads came out of the chair. She made her chair "from" a dragon. I 3D-painted her toenails. My mother is not an actress by trade or pretend. She sat in her chair and the setup was cool. Two exits: Valhalla [a mythological place] or Hell. She had glowing contacts in, and she was holding a glass of wine. When people came to the door, she raised her glass and just said, 'Welcome to hell!' They laughed at her and told her happy birthday, which sort of disrupted a 'terror' atmosphere. She's memorable on her own.

If someone has not bled on a project, it's not complete! You can learn anything from YouTube now, and that was not

always the case, especially how to use these niche things like Pico Controllers. Devices. Regardless of who the person doing the video thought they were making it for, anyone can access. Women are used to working outside of their comfort zone because it is a necessity. You have to keep pushing, regardless of your industry. You can learn almost anything and sometimes it's better to learn hands-on. I wouldn't recommend that someone jump up and run a 4 x 8 panel through a table saw for the first time without experience, but you can learn a lot more now and become capable without anybody's direct tutelage.

Women can come out of the gate with some skills. I had never made a silicone mold or sculpted until the second year of doing the haunt. I sculpted skulls. I used a two-part foam mixing. We made 100 skulls to create a giant bone pile for a scene. I saw someone selling a product and I saw someone making this type of piece. And I experimented. Shrunken skulls look really cool! In haunting, we can make garbage look cool. I push others outside of their comfort zone. You're ready to run a saw! My friend used a router to carve this chair that is sitting in my living room. Character growth! I call myself a mixed media artist. I made this jewelry I'm wearing. I will never hang drywall or blinds again. Nope, two things I will not do.

Don't try this at home. Design and photo by Jes Murphy

CHAPTER 5

DEMENTED AND DIVERSE

"Tolerance, acceptance and love is something
that feeds every community."

—*LADY GAGA,*
SINGER, SONGWRITER AND ACTRESS

I AM PASSIONATE ABOUT demented diversity. Sometimes your geographical location doesn't allow you to practice what you preach about in the organizations and forums you belong to in order to advocate for that very diversity and inclusion. Grey House Haunts is located in rural Nebraska, so we employ literally one loud and proud Latina, for instance. Everyone else is White people. It's because of our population. We do have two-thirds female. Some characters need to be of a certain physicality, so they're likely male. Some characters need to be female. My staff's average age is around thirty.

Two years ago, a mentee moved back here from Omaha. Apparently, the haunt he worked for there was plagued with a lot of bullying and he came back to Holdrege dismayed. Based on my own studies in psychology and career in the medical industry, I

easily identified him as a kid that would be easily bullied. When I did my annual meeting with the staff, I called the problem out: "This will not be happening here. We are a family of freaks. I don't care what you look like or who you love. You belong here, and we need to be protective of each other." In other words, I want them to identity here as "freaks" because it makes us look like a family. In this case, "freaks" is a beautiful and unifying word.

My show is important to me, but people are more important. It is very gratifying to see people evolve. One young woman that I hired couldn't even speak when she started. Something in my gut told me to draw this girl in. Would she ever get loud and crazy? No, but I could put her in filler spots.

"The strongest asset we have is our staff and cast," Scott Swenson said. "You can have the most incredible scenes and animatronics, but the moment you get one person in it for themselves, it can all crumble. As a team, the impact is exponential. The synergy, you create one scare, which then builds into the next scare. You have to know what happens two scares before you and two scares after you. Set them up to get that cumulative effect. Building a family feeling allows for that."

In my actor meetings, with newbies, I seat them in the order of the show. I want them to start having some experience together, bond, before being in the haunt together. My cast learns what their role is. "Jane, you're the grandmother with the chainsaw, then pass off to Scott." This is the Grey House Haunts way.

"Back at Busch, which had to be such an assembly line sometimes, we lined up in the order of in the house," Scott added. "I am a firm believer that casting is 80 percent of the director's job. Give them the tools they need, let them know what the north star looks like. Let them work on their own, redirect privately and praise publicly."

If I had to guess, I bet 40 percent of my cast is LGBTQ. As a result, last year, I added to my speech at my actor training,

"Bullying is too prevalent in this country. We are the freaks, so this is a safe place. The first time someone comes in and makes it unsafe, they are out of here."

You almost have to sense what could be personal or private aspects of someone's identity, so you can foster their best selves in a certain role. For example, one girl suffers from severe anxiety and she was my utility player, which means you can play any position. I had her taking tickets, acting, security. She agreed to all. She told me in the off season that she suffered from anxiety horribly. I never guessed that. She said, "The second I got to Grey House, I felt so safe!" She felt she could function in this weird, creepy, false universe. I've had people who almost couldn't speak and then got into the haunt acting and became so confident. One girl moved away and got a job. She kept thinking, *what would Jan tell me? Be scary.*

I meant, be big! I know you're afraid. Everyone is afraid of something. Be big, powerful. We also have a couple of ultra-conservatives on the staff that have become more open-minded. It's hard to hate someone if you are looking them directly in the face. Theatrics broaden your horizons naturally. We are a welcoming community, and we have mainstream people and so many on the fringe. Our community is built on fantasy. We're supposed to be the fun people.

Despite living and working in a less diverse region, I try to actively stamp out discrimination. I've done a couple of panels. I'm on the board of the Chamber of Haunters. In fact, we're currently working on a committee with women to prevent sexual harassment of any kind in the haunt industry. We're trying to be inclusive as four white, straight, middle-aged women using our platforms.

I would like to give a shout out to a group called Haunters Against Hate, which raises money to assist LGBTQ youth. Haunters Against Hate formed in response to the most unpleasant of circumstances, namely the Orlando Pulse killings and some extremely negative speech made by a haunt review team. As

the group tells it on their website: One haunt owner in Louisville, Kentucky, took a stand and refused entry to reviewers, demanding his haunt be removed from their website. This started a chain reaction that resulted in over twenty haunts endorsing an open letter, which was posted to Facebook. The letter stated to the reviewers that hate is unacceptable, and that they were not welcome at any of their venues. All proceeds from the *The Book of Haunters VI*, which is beautifully designed, go to various LGBTQ youth organizations.

This is what I am referring to when I say a unified family of "freaks." I don't mean freaks in a derogatory sense at all; it's complementary to what we do in the thrills-and-chills business. Sylvia is a strong advocate for the LGBTQ community, which she affectionately calls the "alphabet army" because the letters may change depending on who you speak to.

Scott said, "Some people look at a girl and think you can't be scary, you're a girl. I hate to say that because it's like fingernails on a chalkboard, but some people still have that mentality. When you think of haunters at a trade show, these big, burly guys come in all tattooed up. Then I'm an anomaly because I'm a middle-aged, mild-mannered gay man so people don't think I will be out there scaring people, but I can, and I do. Once you identify a woman, gay person, person of color, I think haunters really embrace diversity. I've done shows on this. A phenomenal woman by the name of Cydney Neil, Queen of Haunts. My heart swells when I think of her. She had a haunt in Salt Lake City. She started as a model and made friends in the film industry. She collected props from horror movies and put this gigantic haunt together, Rocky Point, five haunts that were linear. She formed it so that it could become an acting school. The end result was this gigantic attraction every year. She said the haunt industry gives those people who don't have a place to go, a place to go. They are welcomed with open arms."

Queen of Haunts, the diversity pioneer, is to be commended for her contributions to the industry. According to Think Utah,

under her direction Rocky Point went from 100 guests and $500 in income to nearly 70,000 and over $1,500,000 in its closing year. Through Rocky Point's reign, her haunt garnered international recognition and dozens of awards, including the prestigious Best Special Event and the Best Small Business in the State of Utah, for three straight years, and was recognized as the best haunted attraction in the country until it closed in 2007. After selling her haunt, Cydney was hired to build *The Haunted Hotel*, the first interactive dark walk through for Disneyland in Hong Kong. In doing so, she became the first designer outside Disney's own Imagineering department to design and create an entire attraction for Disneyland.

"There are always exceptions to the rule of inclusion," said Scott. "If you go to any haunted attraction and look through the cast, you will find an assortment of people. In casting for a theme park, we had to cast 1,000 people each year for six different haunts, scare zones, shows, and you would have everything from lawyers to homeless people. Predominantly women. There is not a single ethnic background not represented, the spectrum of sexual orientation. Once you're in a haunt, you have the same passion as common ground, and it's not a passion that everyone gets. We become protectors of one another. I refer to all of these people I work with as my 'after-dark family'. During haunt season, I spend more time with them than anyone. Diversity is fostered by acceptance and recognizing that we are here for the same purpose: Fly our freak flags and scare the snot out of people."

DIVERSE HAUNTED THINKING

Speaking of diversity, everyone has a different take on what a haunted house should be. It ranges from a drive-through haunted house in Tokyo that washes the blood off your car as you're

exiting the old garage, to underground in a cave, a steamboat floating along the Ohio River, a decommissioned power plant, a corn maze, a so-called alien invasion site, a schoolhouse, asylum, and even live stage combat.

Sylvia's biggest concern is dark attractions, or "extreme experiences you have to beg to get out hours and hours later. A true haunted house stops when you want it to. That is the mind of reason. You can control this. You can leave."

There is a difference between terrorize and terrifies. There has to be a place in a guest's mind that ultimately, they are safe. Without breaking character, I want my actors to be able to slither away. Someone crying in a ball on the floor is not having fun, and I want them to have fun.

Sylvia said, "We're taking them into a make-believe world. I've been to some touch haunts. At one in Pennsylvania, our safe word was 'cow' and we had to reach into this bowl of slime, and I didn't want to take my gloves off. They called me a coward and let me go."

The Association of Halloween Haunted Houses made a statement about some extreme attractions, distancing itself, and there have been complaints about misuse and abuse of young female actors. In my mind, when you combine a preoccupation with power and horror, it's a recipe for disaster for guests. They may not understand what they're getting into when the gate closes. It literally may be too horrific, blurring the lines of entertainment and a traumatic experience. If safety of staff or guests is compromised in any way in the name of a scare, this is not an example for diversity that contributes to the industry.

I don't even want my actors walking to their cars alone at midnight. At closing time, actors want to get out of there, take the mask off and sit and have a hot chocolate. They go, *puff! I'm out!* Last year, I designed the process for each zone leader to pick up their actors in each zone and walk together. What if someone hid in the house? They're alone with Sarah, who is still in her

hidey hole. I try to make my staff aware of this kind of thing. Is it fair? No. Is it real? Yes. Last year, we had a female in a room by herself. We did a faux wall that she stood between. No one could hear her. There were actors on all three sides of her. If you aren't hearing anything from Marissa's room, check on her. She could be sick in a corner, could have fainted, could be in an altercation with someone. My female actors are at risk. I cast a lot based on female safety. The odds of one of my female actors being raped while we're open is pretty slim, but they could be assaulted. Any type of assault can be damaging and horrifying. It still alters your life, your view of the world. Besides, this is not what they signed up for. They signed up to have fun and gain experience. I intersperse males throughout the house, so customers will be more accountable. Do male directors do this? I certainly do.

I think it through. If I have three young females on one floor and no man, I'm not comfortable with that. What is the configuration of the room? Are they safe? More at risk because of the configuration? I also tell them that they do not have to be hugged by customers. They're not giving permission to be touched in any way, let alone be wrapped up in their arms. We've had situations that if I had chosen to send a male in, it would have escalated. I can diffuse situations. I put on my "mom" voice and people may call me names, big deal, but no one has a black eye or goes to jail. I've heard horror stories from others that have had to throw people out.

Our first concern is everyone's safety. Secondly, it's the next group.

We don't want them to stumble on a big blowup because they lose their entertainment value. They are attending for entertainment. We need to move people into the next rooms or there will be a collision.

Once, Shai was working in the doctor's room and a guy hugged her and pinned her against the wall, which infuriates me. "I don't know if I handled it the way I was supposed to," she said.

"I swung him around against the wall and kept scaring the rest of the group. I was pissed, but at least gave a creepy smile to keep the scene going."

With that incident in mind, I've taught females how to keep customers far away from them. I never want them to use their hands, they can put an elbow up. Actors don't have to allow others to touch them. It may be the customer's way of dealing with fear, but forced physical touch is not part of the job. Put your elbow into their ribs. It's not a law not to touch customers, particularly if they are becoming a physical threat.

We hired an off-duty police officer for security a couple of years ago, and the touching has dramatically gone down. A girl manages the front yard, and she does not speak. It makes the customers crazy. She's also an attractive girl. Guys want to get her number, approach her. In one instance, I had to intervene. I got close to one man's face and said, "You don't get to make her uncomfortable. You paid to get through the house, not interact with my staff."

We walk this fine line. We're peeling the layers off of people so they get to a space where we can terrify them more easily right from the time that they're on the property outside. We do scent, sound, overstimulation and it's a central nervous system attack. We prep them and then we get them through the door. While we're doing this, I realize that it conversely peels back the expectation to follow normal societal rules, too. We may not do "lights out" night anymore. Customers love it, but from the managerial point of view, it's like "Little Shop of Horrors" in a bad way. We don't have show lights. It's pitch dark with the exception of staircase and entrance/exit lights. Groups of four to six carry through a glow stick. That's it. This gives actors immense freedom because they don't have to hide. They can be anywhere they want in the dark. For a small percentage of customers, it's permission to do anything they want in the dark. You have to plan for this small percentage. You are

responsible for every person's safety—even the drunk, aggressive person who wants to be the big man. We have to plan our shows around those people. How will my actor get away from this drunk?

I have a person in every room. I have closed-circuit security, but more for break-ins and building security than customer watching. I try to have an actor every fifteen feet. I need eyes on customers. Sometimes groups will stall either from fear or they think they're being funny, so an actor needs to press them on.

With the example of theatre, imagine you are a director of a play on stage and imagine twenty-six stages in which the audience winds through, seeing "Macbeth" and then "Mary Poppins." How do they flow through safely and without losing attention? It's an organizational nightmare in some ways.

Jo Breinig as "Isabelle, the Swamp Witch" at Grey House Haunts. Photo by Miranda Mayo

Shai Stroh as "The Priestess" at Grey House Haunts. Photo by Jan Knuth

CHAPTER 6

SCREAM LOUDER

"Write when drunk. Edit when sober.
Marketing is the hangover."

—ASHWIN SANGHI,
NOVELIST

HOW DOES ONE promote a haunted attraction? I'm proud to say that people from cities like Omaha and Lincoln drive out to see us. We also attract Kansans. Over the years, I've gotten a lot savvier about marketing and outreach, which has helped me reach capacity. There comes a point where you do reach max capacity. I don't have a cornfield or factory complex to spread the scares throughout.

There is a haunted trail nearby and I think they do an excellent job, but they have endless space and don't have required sprinklers or parking zones. They can have as many people in that cornfield as they want. I have limitations. Once you get that saturation, you can do other things. If you're at saturation, raise your prices. I was hoping to be there last year. I try to be active in the online haunt community, so I keep learning. I can learn tweaks

for the size we're at. I can adapt. You need to be open-minded and think it through. Critical thinking is a treasure.

Though people may know me as an introvert, someone who shies away from attention, I am a shameless self-promoter that uses guerilla tactics when it comes to drawing new guests to Grey House. We went to a hockey game in Carney, which is five times bigger than Holdrege. Five of us dressed up in costumes and passed out flyers. I will bet we've done seventy football games in the last six years in which two actors would sign up for a game and then go place flyers on every single car at that game. Teenagers are my sweet audience spot. Some parents. Maybe some grandparents, or I know they at least talk about us. I've also done cross-promotion with the haunted trail.

Someone who truly knows about cross-promotion is Mandy Redburn, who started in the industry in 2015 through a nonprofit as a casting director. *Spoiler alert*: This is also a love story! She and her current partner, Chris, had moved away and then they reunited to do this incredible haunted attraction first as a nonprofit together. As she tells it, Mandy was in a horrible marriage and on her way to a divorce. Through the haunt project, she and Chris started dating while collaborating on Bridgeport Gore Grounds, which was in an elementary school. After a successful two-year run, the building was falling apart. Mandy and Chris didn't fall apart with it thankfully! Their haunted home now is complete with three escape rooms and two basements in a four-story building with a tower, making Factory of the Dead in Saginaw the tallest skyline of a haunt in the state of Michigan.

Besides running this mega-complex, Mandy and Chris customize haunt video files and do web design for haunts, not to mention create and market a haunt guide for Michigan attractions.

"Most male haunt owners skip right to Chris and ask him questions when they know that is my department. Our fire

marshal did that to me despite my background in fire service. My dad owns a fire corporation, and my mom was a state fire marshal. I worked for my dad for ten years. The fire marshal totally disregarded me even though I *write* our safety protocol. I backed up a little and just listened. They brought in their own fire department with thirty eyes on us, nitpicking every little thing. Eventually, I got through to him that I knew what I was talking about."

Yep, that is the one person we cannot offend—if we want to open. It's almost like you just have to let them be sexist. Mandy bit her tongue so Factory of the Dead could open. As she says, "sometimes you have to do that for the greater good." This is an entertainment industry, and we want everyone to keep enjoying it. As I say this, Mandy is abuzz with marketing tips and enthusiasm for sharing them with fellow haunters. I really appreciate her insight and generous spirit, given all the pockets of the industry she has her hand in.

"We can share our customer base with each other. A startup reached out a year ago for set design and I had a lot of ideas. We like to assist other haunts. Three years ago, I cofounded Triangle of Fear, between three of us haunts and offering promotions to check out all of them. Networking is huge. Our main competitors are other types of entertainment like bars, restaurants, bowling alleys, not other haunts. This is not a hobby. This is my livelihood. This is what I do. In Saginaw, everyone knows us by our T-shirts. Chris is a marketing genius. Our apparel. Word of mouth. We get involved in community service. I grew up in Freeland and they asked me to put together a trail in Freemont Park, so in 2020, we co-hosted an event with the Lions Club. With marketing, you're talking hundreds, thousands of hours. We have a setup with a couch/bed and TV in a hotel scene, and I will go lay in the bed sometimes. On your website, when people search haunted houses in your city, make sure yours pops up.

In Saginaw, ours is always first. I love doing road trips to other houses, trying a new prop, getting a new toy."

Brian Foreman started Hauntopic, the podcast, in between the dead time and doing his commercial haunt, Dead Factory. "Once you become addicted to the industry, you keep doing it," he said. I suppose this is why I'm also on panels and industry groups and doing this book before getting ready for what promises to be the busiest Halloween season on record. I think the mainstream assumes that haunters disappear in a hole or go back to their corporate jobs until October 1! I couldn't live that way. Neither could Brian, who stays busy year-round.

"I go to the trade shows and go around as press for interviews," Brian said. "They will see the Hauntopic brand and different vendors collaborate. A lot of people know me from the podcast and stop me to talk, but I'm not carrying my mic all the time. I fell in love with haunting myself because it's different passions combined as one. It's one of the smallest biggest industries. I was on the fence on whether to call Dead Factory a haunted attraction and a haunted house because people get confused when you throw in the paranormal haunted house. There is a lot of crossover of people who do like the paranormal. Some haunters don't like horror movies. Then there are actors who don't want to go through the whole house. What is a haunter? Pro haunter?"

Brian's questions are key to marketing and promotion. First, we have to settle on the answers for our own business and stay consistent. We're losing voices if we're not inclusive, but we are an industry of extremes—particularly on social media. We have you sharing your info with everyone, teach and learn at the same time, and then you have another extreme where some businesses want to sexualize Halloween. I personally don't think Halloween is sexy. Make it *scary*.

"Social media feeds ego and narcissism," Melissa Winton said. "We should build each other up. I am hearing it more and

more. This narcissistic feeding of social media is a culture. The haunt industry is funny. There is a level of support I've never experienced before. There is a large acceptance and support vs. other industries, but the haunt industry seems to be stuck in high school sometimes as a race for popularity. The creative ones seem to pass judgment on anyone that comes from a business world. Everyone assumed I was an artist, then they would be totally surprised and rebuffed that I came from a legal background and the business world. James is super artistic, but he is a VP of a corporation. So, then I'm an outsider. If you're not struggling and starving, you're not part of us?"

Factory of the Dead's owner and my marketing heroine, Mandy Redburn. Photo by Chris Hartley, Factory of the Dead; makeup by Brucealinabelle SFX and Kimberlina Sanger

Slayer's Wisdom

LaNelle Freeman on Breakthrough Branding

My mother was a teacher, and she taught in a kindergarten room that had a haunted house in it. We helped her every year do the haunted house. When I worked for the JC, I was charged with directing the haunted house. My oldest kid at sixteen wanted to work at a haunted house, so we started at the Arlington Art Museum in the old Dungeon of Doom in the basement. They were the haunt well-known by everyone. She bought flying monkeys at TransWorld and someone called them "hairy chickens." They did an article describing the hairy chickens. You can make any PR positive for you.

We ended up at Reindeer Manor, a Halloween park of four haunted houses, and then became casting director at Dark Hour, which was so big it could hold a candle to a couple of industry giants. I ended up at Universal and Howl-O-Scream at Busch Gardens. I pushed actors to be the best of the best, and Allen Hopps pushed me to train them. I interviewed actors and it changed everything. When you get in the tech field, and it's driven heavily by animatronics, they want to push the actors out. I don't think that will ever be viable. I've never run a successful haunt with just animatronics. I need in-my-soul actors with the animatronics. We have a mobile escape room. We need hands-on. We need interaction. COVID-19 has changed everything.

A guy started Texas Convention and I respect him infinitely. He asked me to be involved. He lived out of state and two years later, he left it and had all the legal stuff, so it died with him. We wanted to help our local haunters. There are hundreds of haunts in this area. Dallas, Houston, Austin, Oklahoma, Louisiana. Seven of us invested. In this industry, you feel like you are family.

We're all in this together. We need everyone on board to keep

this industry relevant. Some guys don't know they are treating you differently. I wasn't pigeon-holed into being a girly girl. I could be me. I had enough people in my life that I could learn everything from. The best thing my stepfather did one time was not taking a fish off my hook. I thought he was being the meanest man in the world, but I caught a catfish, and I didn't want to touch it. I sat on that bank crying until I figured out how to get the hook without touching it. A pair of needle-nose plyers ended up in my tackle-box after that. I figured out how to do most things, but I could ask for help if I needed it. The same goes for building. If someone gave me a task, whether painting a room, building a room, replacing walls of the dungeon, I would have to match the bricks with whatever we had in stock. When you work for a nonprofit, you use what you have. I will grab a hammer, use a drill.

If you need help, you have to build a rapport and *communicate*. Don't expect guys to look and know what your needs are. I've been married for thirty-seven years. You have to tell people what you need. A man may know your heart, or even God may know your heart, but you have to pray for something. We get busy and we forget to communicate. One thing that has helped me is my background in occupational therapy. We have a minor in psych. Look at actors and where they are coming from, what you're asking them to do. I do an activity analysis, which is breaking down what you're asking them to do with physical and mental. Do they have what they need, or do you have to train them? Break down the activity, what cognitive, physical they need to perform that. What body type are they? Did you spend thousands of dollars on a costume that someone else needs to wear?

I would come at my actors with a pair of scissors. Remember Allen's class with a "broken promise"? If you come toward customers, your promise is to scare them. You have to do a near-miss thing or something. I would practice on actors with the scissors or scream in their face. Which one do you prefer? Haunts

have to be all-inclusive. How many ways to do we learn? Smell, sights, sound. They bought a ticket, you promised to scare them, not annoy them. When fear is turned to anger, you're just pissing someone off and not scaring them. That is why customers want to talk to you—they feel uncomfortable, and they want you to fix that for them, but it's not what they paid for.

With lighting and décor, have one room of black walls, but not every room with black walls. Have sets, props, actors. Conglomeration of smelling, hearing, feeling. Fog or snow, you need it to be an element of the story. I worked in a haunt where the music went out and we didn't know it for five minutes because the actors carried it with sounds and coming in and out. At Dark Hour, we used to call it spoiled for the kids that first started because it was indoors with air conditioner, bathrooms, costume room where costumes were washed every night. In Texas, 100-degrees weather, in latex trying to keep your makeup from running and with ants crawling in your fishnet, all the fun outside stuff.

One night, a prop stopped during the storm and the actor ran out of the room and said, "My prop is not going off." We regeered the training to improvise. We had a fried squirrel in the transformer one night and had an emergency backup. When something happens, add it to your actor's handbook! One addition was: Please wear garments between any costume and fishnet you have on.

I'm very faith-based. We were doubling the Texas Haunters Convention in 2020, and we had so many haunters and vendors begging us not to cancel. It funneled in buyers, not the look-sies, and everyone made their booth and profited, making it worth hosting. During COVID, I was horrified. I wanted to keep people safe and healthy, walking around with an FDA-approved R water from my husband's company. We had a COVID questionnaire and then a follow-up survey. Now, I get calls from the city of

Mesquite asking how we kept people safe. We have all felt disconnected because of COVID. Help one another. Reward people for doing the right thing. This all adds to your branding.

I am so retro and old school. I will always drag the past into the future. You can keep upgrading and advancing tech. I love VR, which will be the thing when they figure out how to pair with computer-generated imagery, CGI. You don't know what is real because they're both coming at you. I saw this at Universal. Detailed sets. Not blood everywhere, but the senses, phobias, classic horror movies infused with some new. Actor startles get me more than animatronics.

Someone asked me how I could be a Christian and still love haunts?

I'm nonjudgmental! I walk the walk. This is my personal brand. You need to be that open with your actors. The only thing I won't do that I ask them to do is stilts. I did bungee, ropes course, but the stilt thing...*no.*

LaNelle Freeman promoting the next Texas Haunters Convention. We both have a thing for skeletons.

LaNelle bringing out her inner witch.

CHAPTER 7

DON'T BE AFRAID TO SLAY

"Life shrinks or expands in proportion to one's courage."

—*ANAIS NIN,*
DIARIST AND NOVELIST

I THINK YOU HAVE to be a chaos junkie to do this haunting business, even if you're doing a charity haunt. I have grown exponentially while making a business out of the weird and twisty. Even more than I did working in the medical industry for more than two decades. My biggest mistake when I established Grey House Haunts was not having more faith in me. I figured something out the last couple of years: there is no one in my show that is irreplaceable except me. I need people to help me, but I'm the only one as owner and director that is not replaceable. There would be no show. It took me two years to realize I need me and then others. This was a freedom for me to figure out. I learned how to use saws! I worked hard for six years to establish market share. I figured out what works to draw attendees. I figured out how to keep the house running smoothly.

I'm always aware of what is going on. I am the sole owner of

the property and Grey House Haunts, LLC. I've taken chances in my life. When I started Grey House, our biggest concern was ensuring there was a buffer between my business and my husband's business in the ag industry. They're not community property. Steve is extremely left-brained, and I am right-brained but hop back and forth. I live in right brain where I sleep at night. I survive on creativity. The back and forth works well for the haunted house industry. You have to address all of these layers and still be creative.

My sister, Jo, expressed that one significant change in me was the realization that I can teach people aspects of this industry. She always saw me as a natural teacher, but she's right; I do have more confidence. The experiences of the home haunt and Grey House Haunts have taught me more than anything in my life, more about myself. I have strength that I didn't realize I had. I have something to offer.

Once, an actor, a young man, literally put himself out there on social and developed relationships. I was sitting on the sidelines of this cool haunt. If this 18-year-old kid can do this, why can't I? So I put myself out there more.

I will share that one of my main concerns with running the business was taking responsibility for keeping everyone safe. Darkness, stairs, stylized tricks, scary noises. Not exactly a safe environment. Wow, I've learned so much.

Every year, I order new signage with my dates, batteries, flashlights, wigs. I don't have a huge staff. Bigger haunts have an owner, director, tech, building, makeup, all as separate divisions. I have Shai, design assistant and makeup artist, and the longer she is with me, the more she understands the business side. I have a wardrobe mistress who assembles the costumes and assigns each item. You might assume that all these beloved items stay tucked away in their cozy, haunted environs, but I bring everything home, or all material would be sitting in dust and spider families—and becoming potential safety hazards.

I also have the three-step rule: Chase someone for three steps, that's it. A taste. You can't just tell someone that this is your space. You have to be specific. One actor was so scary but in the funniest, most entertaining way you'd ever seen. He used the mantra, "Why don't you want to be my friend?" But if someone ran, he would chase them for a block. There is a certain expectation to be scared, but beyond about ten feet, you're getting into a dangerous zone. I don't want monsters huffing and puffing all night from exertion because then you're not scary, you're just on the verge of collapse. When it comes to safety, there are no small mistakes. There is huge liability. I'm not losing everything I own because someone doesn't follow the rules.

You can't stay static in this industry. We still can't grow trees on that one area in the yard when neighbors trampled through to talk to me, Jo and Shai. It became so compacted. We've lost three trees to haunting! Steve's still not happy about it. Jo had small children when we started this. Somewhere in the middle, she and her husband started a mechanic shop, which is wildly successful. In our dreams, Jo and I thought it would be both of us. She didn't realize she would start a business in that time or that it would take off like it has. Most of the people that work with me have an entire and full life outside of Grey House. They keep coming back for more.

She may not know it, but I've seen Jo grow a great deal from this industry, too. Her role evolved from helping to do the lights and answer acting crew questions. One of our actors said, "I really think it would be easy if you had another Jan!" He was right. I would go through a maze to unlock doors and signal actors out. Jo is the only one to help me with lights. We used to shine so much light in each other's faces, fumbling. We've learned a lot by pinpointing what we want to highlight and the effect we want. Now, we could light something correctly in fifteen minutes. Lighting is essential to a haunt. Details are exquisite, Jo insists, but you need lighting to see it.

We lit a room once and didn't want the detail to disappear. I walked through in daylight. It seemed fine, but at night with show lights, it was way too bright. The actor was in a panic and said, "I might as well dance outside!" I took an umbrella and wacked it off the ceiling. Working in the dark a lot affects how we perceive the experience. We work in the dark all the time. We tend to add too little or too much. We're not bats!

Every year, Jo and I would get our walkie talkies and walk through every room to get the sounds right. Does it need a heartbeat? Water dripping? It adds to the experience. This is funny: We would be getting ready to open with walkie talkies and a nearby store employee would start answering us. We switched channels eventually. They knew these messages were coming from the haunt. "I need more blood!"

"When the haunt is going on, we're busy, but we do scare people," Jo explained. "She's not just creeping around to spy on staff. We have Grey House stuff on for security purposes. In the back, there was a fence. When we checked on actors, we would drag stuff along the fence. She scares people all the time and doesn't mean to."

I'll never forget two years ago, Chase, an actor about 6'5" and large, sitting behind a crib with a teddy bear mask on. Customers would come around and he would pop up. I came into his room, the nursery, and a group was in the next room and a group entering the nursery. I had nowhere to go. I was trapped. I had to hide, now. I looked at Chase and said, "I can make it." I put my foot in between his legs on his chair and leaped over him like a spider monkey. I successfully found a hiding spot! What else could I do to keep the party going?

Goofy moments and all, every show is so exhilarating. As Jo will tell you, "About an hour in, Jan gets this beautiful high. This moment. Gears are greased and everything is rolling. It's a peacefulness. Sweet spot."

I hope to encourage other women to not be afraid to slay.

Don't be a scaredy cat when it comes to your passion, whether it's an entire business or a project. I have to agree with Melissa Winton, who said, "Our biggest problem as women is that we have been groomed into believing we have to compete with everyone for everything, especially our own sex. In the last year, women supporting is more visible than stepping all over each other to get to the top. If we can get past this brainwashing of being the best, we can be at any cost."

Just think of what we all went through in 2020. Colossal unknowns and major industry barriers that became owners' worst nightmares. Social distance didn't go with the words, haunted attraction, for starters. But I only see growth now. Grey House is landlocked, so it won't be growth in crowds necessarily. Would I start another haunt? Possibly in a larger town. But when I think about starting everything again and a much longer commute, not sure. Then I look at abandoned buildings and I want to convert them all into haunts. And I wonder if they already have a sprinkler system.

Can we grow in design splendor and storylines? Always. Growing *is* slaying. Year four, we were finished building. It could have run that way for a couple of years, but stagnancy doesn't make the best show for customers or the most fun for us. I adapt a little bit within my footprint every year. In 2020, we changed some rooms that had never been changed in terms of props and style. Since we are a smaller footprint, this may seem backwards since most haunters want throughput. How many can I push through in one minute? I have to balance throughput with quality of experience, which also entails length of time. I have 7,000 square feet, which you can get through in twelve minutes. I want the experience to be longer. I can make the experience longer without effecting my throughout except by maybe ten seconds. For instance, if I add more jigs and jogs and blocks, that slows down the group inside, which makes me hold the admitting group a little longer.

At the end of the night, if you count, you may have lost the time of one group, but the show was more riveting. We do groups of six every sixty seconds. Part of it is you want to avoid congo lines smashing and moving along. For some slow groups, I will hold the line for three minutes. They paid their money, too. I've been on the phone or radio barking before asking, "Why is no one exiting? Where is everyone?" Then I'll see thirty people burst through the door together.

We're on a motion sensor timer. No one needs to know the tricks behind the scenes (like my trustworthy bell ringing for each group, *wink wink*). If you have a property that is a long way from the driveway entrance, a doorbell sensor can go off in the kitchen when a car enters the property. If I told a human to send people in every forty-five seconds, it wouldn't happen. I want my gatekeepers, or ticket takers, to be chatty, stern with rules, have a backbone and be likeable so they will start talking. That can eat up several minutes though, which translates to cash lost. I took this step out of their hands because they get distracted. I was making them fail at this and it's not their fault.

I gained this through my medical career: most of the time that my staff is failing, it's because of something I did or didn't do. With the gatekeeper, if they are constantly distracted by engaging, which I asked them to do, it's my job to make the adjustment. It's a lot of coordinating. It would be nice if we were big enough that I could hire someone and say, these are the things you watch, and I watch other places. The first night is always the roughest. Is the sensor working and in the right place? We don't want people to stay in line for two hours. In 2019, I had to expand my que and make sure people weren't standing in the street.

I can almost hear you thinking, wow, so many parts to a haunt! I won't lie. "ADD" and "ADHD" have come up for people in this industry. Is this accurate? Allen Hopps read me on this topic: "Boy, when you're talking about mental illness and the diagnosis of, you

have to be careful about speaking for these topics. I think as artistic people, we may be a little scrambled and have our focus on a lot of directions. Maybe our brains are not linear. We can pull from here and there to make a seamless show. I was actually tested as a child for ADHD and I'm on the opposite end of the spectrum. I can focus on one thing and may not even hear you call my name. I'm hyper-focused. One of the reasons I started doing video is to force myself to pay attention to other things. I don't see a huge overlap in ADHD and haunts, but it's possible. You have a lot of people that say they are OCD and what they mean is they like to see things neat and orderly not compulsively hurting their lives by this orderliness. In the last fifteen years, there is this overstatement of certain conditions. With haunts, there is so much that has to be done, you have to fully function. Guest safety, staff safety and these are not the creative departments of operating a haunt. You have to function at a high level to run an attraction."

Based on my chat with Shannon Hopps, Allen's wife, I think she is high functioning! She married into the industry. She was a patron for many years, going to as many haunts as she could and when she married Allen, she began working on the other side and thus, joined the industry.

Their company, Stiltbeast Studios, hosts Monster Camp, a fully immersive hands-on weekend designed for serious students to learn the mask-making process. How wicked fun is that? The company offers a host of other top-notch services, but I'm still stuck on Monster Camp. Shannon says they stand out as a result of their "positive and inclusive attitude to share knowledge. We want the industry to rise, improve and enrich and a lot of that comes from our style of instruction. We travel all over the country teaching actors and owners how to put on a better, safer and higher caliber show. Our Monster Camps and Labs are open to anyone who wants to learn at any skill level the art of mask making, airbrush and more. We are probably one of the most accessible businesses in

the industry, constantly posting free tutorials and information on YouTube, answering emails, messages every day. We do not disappear in November." You'll see the level of detail in their year-round schedule when we hear from Allen soon.

When I asked Shannon about the most rewarding aspect of their business, her response is similar to what I would say. "Watching people who did not think they had the talent realize they can meet their goals. Actors who are untested facing a new challenge and excelling. Artists who want to try their hand at mask making, intimidated by the process and creating something with their own hands from their own design. It's very emotional and rewarding to see them flourish. The most challenging is finding time to do it all. We are always inspired by the work of our colleagues. It is beautiful art they are creating in these shows. Whenever we have had a chance, we go to their shows to see how they operate. It is hard to do when the season is full swing, you're so busy. Legendary Haunt Tour is a must, it is the only chance we can see pro haunts in full operation. And if we are delivering an order and there is a chance for a tour, we go. We can learn so much from each other."

How does Shannon feel that more women can rise in the industry and be supported? I'll just say right off, I am inspired by her response. "I want to see them support themselves rather than *be* supported," she said. "I see as many women in this industry as men. Haunt casts have as many women as men if not more. Create what you need. If a mask does not fit a smaller female face, learn to make a mask for yourself. Stretch boundaries and choose a character that is new instead of one that has been done over and over. Women can also learn the business side of haunting (this is what I call the 'unsexy work'). It is not as much fun as acting or creating, but it is always going to be there, and it is full of challenges. It also gives you an insight to what makes a show come together and thrive. Most of all: Build your show. Get in there and get dirty.

Paint, hammer, drill—all the hard work. Learn how to use tools and muscle and build it. It is your show. Do more than show up for rehearsal and get a costume issued to you. You are more invested in a haunt that you helped put together. You'll learn excellent skills that will serve you all your life."

HAUNT COUPLE ALLEN AND SHANNON HOPPS AND
ONE OF THEIR FAVORITE TRANSFORMATIONS.

THE ALLEN AND SHANNON HOPPS WE ALL KNOW AND LOVE.

CHAPTER 8

TERROR TAKEOVER

*"Monsters are real, and ghosts are real too. They
live inside us, and sometimes, they win."*

—STEPHEN KING,
AUTHOR

A S YOU CAN imagine, haunters exchange countless
tales of working in this industry. If we didn't, I'm not
sure we would be doing our jobs in entertainment.
Unpleasant moments are par for the course. One man went to
the police for "scaring" his child, who had already gone a quar-
ter way through. The ladies that work the ticket booth discour-
age children from going in. They're already warned and buy the
ticket. The kid was ten years old. The dad screwed up and said
her name, which we used. It's a haunt, an immersion experience.

Let me be the one to say it: A certain amount of responsibil-
ity lies on the parent. Our actors don't want to make children cry.
When I say I don't want children of a certain age to enter, it saves
a lot of grief. If an actor makes a child cry, the actor may not
be effective for a few groups. A grown man threatened a teenage

actor after he terrified the hell out of him. The chief of police smartly inquired, "Didn't they do what you paid them to do?"

For the last couple of years, Jo has worked at the exit. She sees it all! Or at least she sees what I don't see. People love a good photo op. She's very friendly and loves to talk to the customers. Working the entrance is harder because you don't know what to expect from people yet. When they come out, they're mainly excited and want to talk about it. With that hidey-hole where people don't see me, I can hear their conversations and people take to Jo like they've known her forever.

I think I would be lost without all these stories to share. While crackling with excitement over seeing our fellow haunter friends in person again on the trade show circuit and then each other's attractions, we've been trying to pinpoint what the next era of terror will be. In ways, we're obviously in charge of creating it and becoming even more inventive.

Scott Swenson, whose creative mind never stops, advises, "I refer to it as the Wild West. We don't know where things are going. Anyone who claims to is making things up. I was lucky because none of my projects cancelled; they postponed. During the downtime, I took a certificate course at University of South Florida called Post-Crisis Leadership. The only way to prepare for the next crisis is to stay prepared: have multiple possibilities, don't have one supply chain or way of doing things, keep your mind open. I've tried to experience as many attractions as I can. Someone said, 'Let's do a drive-thru haunt.' I heard that a haunted hayride did really well, but it's a monumental task or you have to be very clever in right-sizing your script to your location. I mean, if you're a hayride and you put the cars in, it seems like you've got a leg up! One I drove through was trying to create an entire fantasyland in a cow posture. They didn't have the money for that, and it showed. I'm working with a client who wants to open a hybrid haunt-escape room and we're looking at how we take

virtual aspects and include them. Where is the industry going? I really have no idea, but the industry will continue. We've been telling scary stories since we knew we were people. A saber tooth cat scares in a cave painting. Format changes, but the industry stays. What makes people successful is their ability to let go of what they did in the past and adapt. We've changed the way we as human beings behave. After twelve weeks of doing something, your behavior pattern is changed. We're meeting from three different cities on Zoom. Recognize the new normal."

People want a bookmark to success, and my response is always the same: When Grey House Haunts paid for itself the first year, that is when I became "successful." It brings me joy and reward, fulfills me creatively, and the moment it doesn't do that, I probably won't do it anymore.

SLAYER'S WISDOM

Allen Hopps on the State of Industry and Future Trends

My life is seasonal. I do several things. January, February, I'm getting ready for TransWorld to sell products to houses all over the country. There is a Renaissance Festival in the spring where I display all the monsters that I make in a museum I own. As soon as that festival is open, I start filling the orders placed at TransWorld, which runs me into June. I'm getting ready for Dark Hour in Plano. It overlaps. July, August, you're full tilt getting your own show ready, and August and September, I'm on the road doing actor training for other shows and come back in time for mine to be open. You have to do repairs, maintenance, upkeep, hustle to get your cast in order. Every week, you hire folks to fill jobs.

Some societal traits make job hopping more common, and haunted houses are a lot of work. In November, cleanup and you

have to put the show to bed. I do a big chunk of business for shows that are open for the holidays. The whole world shuts down for maybe a couple of weeks from before Christmas through New Year week. Then it's TransWorld again.

I did my first haunted house at ten years old and the only year I didn't do one was 2020. I fell in love and moved from Maryland to Florida and worked for a year on Terror on Church Street and I worked for a year on Skull Kingdom. I would take a vacation in October and work at different haunted houses around the country. When I worked on one in Texas, I met my wife, so I moved to Texas. This was before the Internet then with the Internet, I started a YouTube channel on how-to stuff for haunted houses. I sell stuff, make stuff. I direct a house in Texas.

There was a boom in the 90s and it started because of Distortions, another company, that made a prop called the electric chair that sold for $1,000. Most big haunted houses bought one, but that was the first big-ticket item for haunted houses. This said I can make money selling to haunted houses. We had trade shows, party shows, that sold to retail and this was before Spirit Halloween. It was Spencer's in the mall. Those shows eventually split into retail and haunted house. We're in the user space, not resellers. I still say Home Depot gets the most money around Halloween. As far as specialty items, the connection is made at TransWorld. When it became a haunted house show, adding the electric chair. Silicone masks. Then Brainstorm changed how graphics are done. Before, it was like the March of Dimes style of hand drawings. Brainstorm, early 2000s. The theme parks jumped into the game around '98 or '99 with Universal and Six Flags. I'm still looking forward to complete legitimizing of the industry. People expect you to set up in a month and then be out. These attractions can be so much more.

We don't have a body that can effectively police ourselves, and most attractions are not sizeable enough to get their own

policing. Do most pay their fair share of taxes? I don't know. Here is a big issue: Most haunted attractions do not pay their actors. They are working for your for-profit business. If you aren't paying, then it's a hobby. You can't claim that it is a business. You have to pay your staff. If you can't afford to pay your staff, adjust your business. When you get to pay and insurance, that legitimizes any industry. The history is haunted houses were made widespread by the March of Dimes in the eighties. JC's haunted houses were volunteer organizations that worked for a charity. Not paying actors was standard. That era is over. Most haunted attractions are for-profit houses. I don't know that it is a professional business unless you are taking care of your staff. How can we claim to be a legitimate industry when 80 percent of people are supported by a different industry?

Regarding gender, I assume Christmas is the guy and haunted house is female. Break it down to makeup use. Home decorating is makeup for the house in my brain.

Shannon brought me into the Renaissance Festival world. She would go to five haunted houses a year. I want to spend time with my wife, so I got her started working in the haunt. In the first years of our marriage, I made everything but since I involved her in the business or she wanted to help, my business has grown five times because I have someone more clerical-minded. Haunted houses are a business, but it is the business of art. We're selling art. We have to market art.

You can have a beautiful haunted house, but they don't do marketing. Then you have a great marketer, but the house is garbage, but they rake it in because they market well. I also think that we as attraction owners and designers, we overestimate the involvement and needs of the customer. This is clearly shown when you get exit surveys, and you spent a month making a new Frankenstein set. What is your favorite thing? You get an answer that says, 'Where a fishing line touches you like a spider

web.' I run a multimillion-dollar haunted house. We design a vortex tunnel that spins and makes you dizzy. Sometimes they just want to see a skeleton coming out in the dark. It's meeting the basic needs, but we go above and beyond. My friend, Alex, says, 'Nobody leaves a haunted house and says how awesome the crown molding was.' We obsess over this though because we see the haunted house six, eight, ten months a year and they only see it once a year. Their view of what a haunted house is, is very different from ours. We have to change our viewpoint a bit to see what makes the best haunted house for the customer. Think about what delights a guest and maybe you can pull back on something that makes it more successful financially.

I made a live video for my new Krampus mask. I said this at the end: Haunted houses are often seen as darkness, but it does not negate light. In order for light to be successful, there has to be darkness. It's a balance. Haunted houses put a face on our fears. People are afraid of not making the mortgage, and they can't scream about that. People are worn down from traffic, but they can't cry and scream at that. We need a cathartic release that haunted houses bring. When you go, it puts a face on fears they already have, and it's something they can look at, scream at and have release in their lives. This release is necessary in their lives. A hero is judged by their villains. That is what makes them stronger and more awesome. Humans are judged by their monsters. The world needs more monsters. When we negate monsters in our fiction and in our lives, we're making a void and then people need to become monsters in order to fill that role. We are seeing that. I don't like haunted houses that depict real-life stuff. If I want to see that I will watch CNN. There is no fantasy. You will see more fantasy elements now like witches, ghosts, werewolves, because the real world sucks. It is scary enough. Breathing the air can kill you! How can we compete with that, scare to scare? There was a boom of this in the 90s and it pulled away as we started

to get haunted houses that were asylum-based, hillbilly-based, clowns. While clowns are scary, they're also reality. State of the world is that it needs us, our public service of cathartic release. If you look at the exit of a haunted house, you see people releasing, laughing, excited. An antelope never feels more alive than when it just escaped a lion. We have made the world so safe that we no longer have that I-survived feeling on a regular basis. Having an I-survive feeling is emotionally necessary for us until we evolve further. We have animal brains.

IF EVERY DAY WERE HALLOWEEN

"We don't create a fantasy world to escape
reality. We create it to be able to stay."

—LYNDA BARRY,
CARTOONIST

ONE THING THAT Scott and Allen didn't mention is this new trend of "quar-horror" that was featured on NPR. All over YouTube, you can find inventive home-made horror shorts taking the pandemic as inspiration, and even the movie, *Host*, filmed over twelve weeks in quarantine and entirely on Zoom, debuted on the horror channel Shudder. Creatives used their frightening real-life episodes to produce something they could share with others. Many haunts continued and adjusted for COVID-19 restrictions and new ones popped up.

LaNelle informed me that Universal had the full plexiglass up with actors behind it. One girl's job at every ride was to squirt

hand sanitizer in each person's hand before they went in. A camera at Six Flags has a camera on your head as you walk through to check your temperature.

Mandy's Factory of the Dead had a large enough operation to open, with the addition of a lot of plexiglass. She said they did online ticketing and walk-ups, and in the parking lot, numbered barrels to create sections. They took temperatures and hired a couple of people to just sanitize. It was the best year since the haunt's inception.

And Melissa's company had to turn away business because the No. 1 shirt people have printed are black shirts in the Halloween industry. Black Lives Matter bought all the black shirts and suppliers were dying shirts black and that caused a shortage of shirts in other colors. They were contacted for 2,000 shirts in one order. It was pretty insane, but they kept going.

In Scott's world, he loves the blank page because nothing is wrong. COVID-19 simply helped him come up with new ideas, like a family-friendly zoo-wide event. 'Spooky: We'll startle the giggles out of you.' They had a dance mob of scarecrows and the costumes needed masks. What do you get? Fabric masks that looked like burlap and a little eye makeup, plus an automatic smile.

And we simply can't ignore everything happening in the digital world to engage and haunt us, like Secret Library, a ninety-minute digital performance combining live actors with puzzle elements. This experience ventures beyond the common videoconferencing experience to include an integrated «stage» to encourage immersion. Search for clues, question characters with suspicious intentions, and work collaboratively as you uncover the mysteries surrounding this ethereal realm of knowledge.

For the latest in immersive entertainment, I have to give a shout out to EPIC Entertainment Group, who designs and produces attractions like no other, including Queen Mary's Dark

Harbor, Night Garden and Ice Adventure Park, keeping our senses and imagination alive. All attractions do not have to be Halloweeny to be mysterious and fantastical in the most satisfying ways.

Each year new props come out. There are VR haunts now, drive-in haunts where you park your car, watch a movie and get scared by actors. About thirty minutes away from Grey House Haunts, a car wash haunt with crazy, creepy clowns popped up out of some creative genius's mind.

For me, I'm not looking for the next Goliath spider. Or wall of snakes. My mind does just fine.

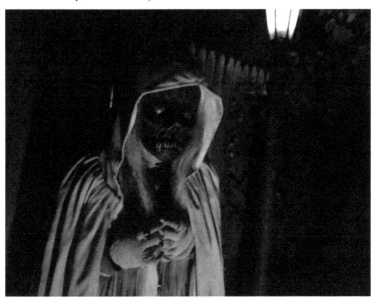

SHAI STROH AS "THE ORACLE" BIDS YOU GOOD NIGHT FROM GREY HOUSE HAUNTS!

REFERENCES

Interviews by the Author

Jo Breinig. Zoom interview. December 21, 2020.

Shai Stroh Christensen. Zoom interview. December 21, 2020.

Caisey Cole. Zoom interview. December 18, 2020.

Brian Foreman. Zoom interview. December 7, 2020.

Lanelle Freeman. Zoom interview. December 8, 2020.

Sue Gray. Written interview. December 7, 2020.

Allen Hopps. Zoom interview. December 8, 2020.

Shannon Hopps. Written interview. December 6, 2020.

Jess Murphy. Zoom interview. November 30, 2020.

Mandy Redburn. Zoom interview. December 11, 2020.

Scott Swenson. Zoom interview. December 1, 2020.

Sylvia Vicchiullo. Zoom interview. December 11, 2020.

Melissa Winton. Zoom interview. December 8, 2020.

Publications and Online Homes

America Haunts. *Facts.*
https://www.americahaunts.com/ah/facts/

Cassar, Ken. "Home Improvement Sales Climb as Shoppers, Especially Women, Migrate Online for Home Goods." Rakuten Intelligence. May 16, 2019.
https://www.rakutenintelligence.com/blog/2016/home-depot-lowes-post-big-gains-online-shoppers-especially-women-migrate-online-home-goods

Chamber of Haunters.
https://chamberofhaunters.com

Dark Hour.
https://darkhourhauntedhouse.com

The Darkness.
https://www.thedarkness.com

Deceased Farm.
http://www.deceasedfarm.com

EPIC Entertainment Group.
http://epicentertainmentgroup.com

Factory of the Dead.
https://factoryofthedead.com

Graystone Haunted Manor.
https://www.graystonehaunt.com/attractions.html

Halloween Forum.
https://www.halloweenforum.com

Haunt Shirts.
https://hauntshirts.com/collections/haunt-shirts-tees

Haunted Attraction Network.
https://hauntedattractionnetwork.com

Haunter's Hangout.
https://hauntershangout.org

Howl-O-Scream.
https://buschgardens.com/tampa/events/howl-o-scream/

Kiss Online.
https://www.kissonline.com

Lake Joy Trails of Terror.
http://www.lakejoytrailsofterror.com/

Meagher, Brennan. "Dissecting Fear." *A.* Augusta University.
September 18, 2017.
https://magazines.augusta.edu/2017/09/18/dissecting-fear/#

Midwest Haunters Convention.
https://www.midwesthauntersconvention.com

Netherworld.
https://www.fearworld.com

Nightmare Nomads.
http://www.nightmarenomads.com

A Petrified Forest.
https://www.apetrifiedforest.com/index.html

Prince, Rashawn. "8 Reasons Why "The Exorcist" Is the Scariest
Movie Ever Made." *Taste of Cinema.* February 3, 2017.
http://www.tasteofcinema.com/2017/8-reasons-why-the-exorcist-is-the-scariest-movie-ever-made/

Queer Forty. "The Book of Haunters VI, a Chilling Love Letter
to the LGBTQ Haunt Industry." *Queer Forty.* October 2, 2019.
https://queerforty.com/the-book-of-haunters-vi-a-chilling-love-letter-to-the-lgbtq-haunt-industry

Reindeer Manor.
http://www.reindeermanor.com

A Scott in the Dark.
https://ascottinthedark.podomatic.com/

Scream Hollow.
https://screamhollow.com/

Secret Library.
https://www.secretlibrary.io

Smithsonian's National Zoo. "Goliath Bird-Eating Tarantula."
https://nationalzoo.si.edu/animals/goliath-bird-eating-tarantula

Stiltbeast Studios.
https://stiltbeaststudios.com

Texas Haunters Convention.
https://www.texashauntersconvention.com

Think Utah. "Cydney Neil." *What Do You Think Utah?* October 19, 2015.
http://thinkutah.org/cydney-neil/

TransWorld's Halloween & Attractions Show.
https://www.haashow.com

Ulaby, Neda. "New 'Quar-Horror' Films Show Staying at Home Is Scary Too." *NPR.org.* August 3, 2020.
https://www.npr.org/2020/08/03/897314108/ new-quar-horror-films-show-staying-at-home-is-scary-too

Universal Studios Halloween Horror Nights 2021.
https://www.universalorlando.com/web/en/us/things-to-do/events/ halloween-horror-nights

Yuko, Elizabeth. "13 of the Most Bizarre Events of 2020 (That Have Nothing to Do with the Pandemic)." *Reader's Digest.* November 11, 2020.
https://www.rd.com/article/most-bizarre-events-2020/

Zombie Army Productions.
http://www.zombiearmyproductions.com/about.html

ABOUT THE AUTHORS

Jan Knuth became fascinated with Halloween as a child and acted on that passion in 2007 when she started a home haunt, which ran through 2013. She then went on to become the sole owner and director of Grey House Haunts, a Halloween haunted house, in 2014.

As a haunt owner, Jan is involved in all aspects of the business including concept/design/build, actor training/management, makeup team, marketing, director, and business manager. Coming from the medical field in her "normal" days, Jan applies problem-solving skills and creativity to her haunt, helping it to grow 15% to 20% each year it has been in business. In 2019, with the goal of helping the haunt industry continue to grow and thrive, Jan joined the board of the Chamber of Haunters as 2nd vice-chair.

Not Afraid to Slay is her debut as an author.

Candi S. Cross dressed as Raggedy Ann on her first wild Halloween night out as a toddler. She is the founder of You Talk I Write, a modern ghostwriting agency. She has co-developed approximately 150 books with authors worldwide. Candi is committed to helping diverse individuals with contemporary stories that make a difference. She lives in New York City with her wife and 24/7 muse, Liza. For more info, visit *www.youtalkiwrite.com.*

CPSIA information can be obtained
at www.ICGtesting.com
Printed in the USA
BVHW091329010721
610979BV00022B/1649

9 781736 836705